Susanne Deicher

PIET MONDRIAN

1872 – 1944

Structures in Space

TASCHEN

KÖLN LONDON MADRID NEW YORK PARIS TOKYO

FRONT COVER:
Composition with Red, Yellow and Blue, 1928
Compositie met rood, geel en blauw
Oil on canvas, 42.2 x 45 cm
Ludwigshafen am Rhein, Wilhelm-Hack-Museum

ILLUSTRATION PAGE 1:
Lozenge with Grey Lines, 1918
Losangique met grijze lijnen
Oil on canvas, diagonal 121 cm
The Hague, Haags Gemeentemuseum

ILLUSTRATION PAGE 2 / BACK COVER:
Piet Mondrian, c. 1920
Photograph
The Hague, Haags Gemeentemuseum

© 1999 Benedikt Taschen Verlag GmbH
Hohenzollernring 53, D–50672 Köln
www.taschen.com
© 1994 ABC/Mondrian Estate/Holtzman Trust
Licensed by ILP/AT & TV Merchandising Concepts GmbH
Osterwaldstr. 39, D–80805 Munich
For USA and Canada:
© 1994 MBI, NYC/Mondrian/Holtzman Trust
© 1994 VG Bild-Kunst, Bonn, for the works
by Braque, Delaunay, Picasso
Editing and layout: Christine Traber, Cologne
Cover design: Catinka Keul, Angelika Taschen, Cologne
Translated and typeset by ITR International Translation Resources Ltd., London

Printed in Germany
ISBN 3–8228–5973–7

Contents

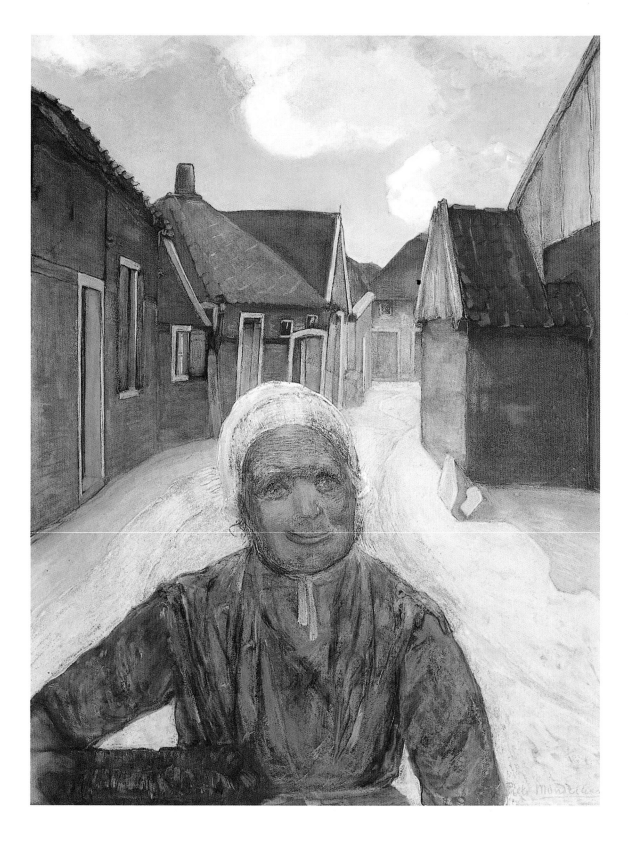

Church and Home – Early Idylls?

Mondrian's abstract *Composition 2* (p. 63) dates from 1922. The plain white ground dominates the painting. The white centre is framed by black lines which themselves are surrounded by small coloured rectangles, blue on the left, yellow above, and red on the bottom right. They seem to want to be read in a clockwise direction: the eye travels around the empty centre of the picture and this movement makes the black lines and bright rectangles appear to be straining outwards. The arrangement of the colours in outlined box shapes on the white surface could be different and appears changeable. Mondrian repeatedly referred to the rhythm of his paintings: they are not intended to appear static, but moving.

The rhythm of the forms arouses different moods. The basic hue remains cool. While some paintings are dominated by a vibrant palette of bright colours, others remain clear and distanced. Mondrian loved jazz and his paintings might be seen as improvisations on the basic theme of colour – like the riff of a trumpeter, devised and executed in an instant but part of an unending series of free variations.

In reality Mondrian often worked for months on end on a single painting, applying layer after layer until he was satisfied with the result. In 1914, at the height of his most radical experiments, he declared his desire to make modern painting classic, comparable to the "architecture of the ancient Greeks". Notebook jottings record his inner dialogues with the Old Masters: "Rembrandt, are we going wrong or aren't we?" In his view, the major problem with the painting of his time was that abstract pictures often looked merely "decorative". Mondrian wanted to combine tradition with innovation to make abstract art appear to flow in natural evolution from the great painting of earlier centuries.

Piet Mondrian was born in 1872 in Amersfoort, a sleepy Dutch provincial town which, like many others in the Netherlands, still seemed to be dreaming of its heyday in the "golden era" of the 17th century. By the 1870s, however, poverty was prevalent, and to escape the harshness of everyday life people often retreated into the fantasy world of religious fanaticism. Mondrian's father, who was headmaster of the local primary school, was one of these religious zealots, and commitment to the Protestant Church ruled his life. He was unable to provide his family with a comfortable lifestyle. The school's records show that the house in which Mondrian grew up was in a poor state. Mondrian's mother was frequently ill, and at such times his eldest sister, Johanna Christina, born in 1870, had to take over the running of the household. She was barely eight years old. Under her "direction" the household with its numerous small children must have been chaotic. Instead of helping, however, their father would voluntarily take on extra teaching, and often travelled in the service of the church.

Piet must have lost his trust in the world and humanity at an early age. Like his sister, Johanna Christina, he never formed a lasting relationship and was always concerned for his own psychological stability. His sister had continued to live

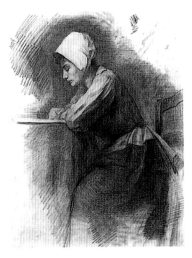

Girl Writing, c. 1892–95
Schrijvend meisje
Black chalk on paper, 57 x 44.5 cm
The Hague, Haags Gemeentemuseum

ILLUSTRATION PAGE 6:
On the Lappenbrink, c. 1899
Op de Lappenbrink
Gouache, 108 x 86 cm
The Hague, Haags Gemeentemuseum

Around 1899, while working on idyllic landscape portrayals, the young Mondrian evolved an approach to painting that was highly individual in terms of contemporary art in Holland. In this gouache, the smiling farmer's wife and the vivid colours transform an ordinary street in the small town of Winterswijk into a scene of calm conveying a mood of particular contentment. A similar atmosphere can be found in all of Mondrian's later work.

with their father until he died, and in a letter in which he wrote about her state after their father's death, Mondrian refers to a "protective barrier". Unlike her, he had to cope with emotional distance from his father as he grew up and embraced the imaginary worlds of art, in which he discovered a "new life", as he often put it.

In the last interview before his death Mondrian related how his father had taught him to draw at an early age. They would work together producing devotional lithographs for the church. When Piet entered the Art Academy in Amsterdam in 1892, his father found him a room with rich, influential Protestant friends. He probably persuaded them to pay for his son's studies as well, being unable to do so himself. On arrival in Amsterdam, Piet immediately joined a radical Protestant congregation, the Gereformeerde Kerk, which still exists today and which, before 1900, was in close collaboration with the conservative, so-called Anti-Revolutionary Party. He went on to make a whole series of religious illustrations based on 17th-century examples (p. 8). Although he was later to become the leading innovator of modern painting, Mondrian at that time accepted the constraints of his church, with its opposition to modern art.

Why was it that Mondrian willingly submitted to the discipline of this fiercely retrogressive institution? The Gereformeerde Kerk saw itself as a fortress and an island within Netherlands society, confronting the onslaught of rapid change during the second half of the 19th century. Its members wished to control the radical upheavals that seemed imminent at the turn of the century and to ensure that events would take the "correct" ethical course. They were not prepared to acknowledge the weakness of their position. Their response to the new age was an apocalyptic vision of the world ending in a "great conflagration", followed by a "new life" for all. They prepared themselves for this by setting up small autonomous groups within their church organisation, where life was regulated according to their principles. Mondrian found his own desire for a "new life" mirrored in the church. He saw that this dream could also be defended in more modest language, with the aid of aesthetic statements whose degree of realism might be small, but which nevertheless held a seemingly irresistible attraction for the imagination.

ABOVE:
Pieter Panis Beheaded in Mechelen, 1671
Pieter Panis te Mechelen onthooft
Illustration from Adriaanus Haemstedius,
De Historie der Martelaren, Amsterdam 1671

MIDDLE:
Pieter Panis on the Gallows in Mechelen,
1896/97
Pieter Panis te Mechelen aan de galg
Illustration from D.P. Rossouw, Mede-erfgenamen van Christus, Amsterdam 1896/97

Landscape with Ditch, c. 1895
Landschap met sloot
Watercolour, 49 x 66 cm
The Hague, Haags Gemeentemuseum

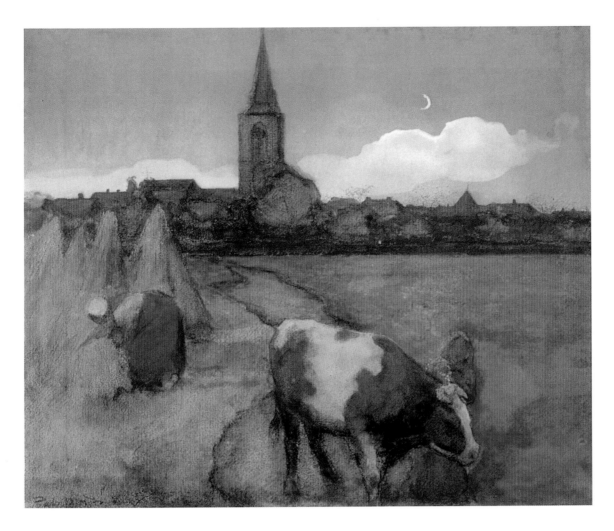

View of Winterswijk, 1898/99
Gezicht op Winterswijk
Watercolour, 52 x 63.5 cm
Amsterdam, Private collection

Rembrandt, with whom Mondrian later liked to compare himself, grew up in Leyden and attended the Latin school and the university there. He enjoyed the advantages of the full range of education available in his time. Rembrandt's artistic career, brilliant at the outset, was advanced by contacts at Court. In Mondrian's lifetime, however, an aspiring artist no longer stood at the centre of society. He was not expected to understand the world. In these early years there was little to indicate that this strictly Protestant young man from the provinces would succeed in changing the face of 20th-century art. Inhibited by lack of funds and education, Mondrian also appears to have been psychologically unstable and to have become increasingly withdrawn. In 1897 he spent the entire year with his brothers in the country. After a disastrous vacation in the company of a girl from his art class, he returned home and remained with his parents between autumn 1898 and summer 1899, recovering from pneumonia.

During this period, and perhaps for the first time in his life, Mondrian's output was prolific. He produced whole series depicting the small town of Winterswijk. The view of the church tower in his home town was a particular favourite (p. 9); he would take his sketch pad and place himself by the hedge in his parents' garden. He worked the drawings up into watercolours, showing country folk in the village-like streets of the town (p. 6), or at work with their

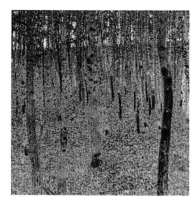

Gustav Klimt
Beechwood I, c. 1902
Oil on canvas, 100 x 100 cm
Dresden, Moderne Galerie

At Work / On the Land, 1898
Aan den arbeid / Op 't land
Gouache, 54.4 x 78.7 cm
The Hague, Haags Gemeentemuseum

animals (p. 10). It is clear from these pictures that his studies at the Art Academy had at the very least made him aware of the problems that absorbed the Amsterdam artists.

Mondrian's drawing of a *Girl Writing* (p. 7) presumably dates from his time at the Academy. His teacher, August Allebé, had encouraged him to draw studio models as if they were figures taken from real life. The teacher's studies showed the girls as tired dancers or actresses, which they may well have been. But Mondrian portrays the model as a picture-book country girl, with stiffly-starched headdress and apron, looking as if she is writing with some difficulty. The plaster block in place of a table shows that the drawing was done in the studio. Mondrian exploited the artificial conditions of the artist's workplace to simulate an old-world, idyllic life, which even then had virtually disappeared. It suited his own inclination towards traditional values. His version of the figure is effectively an invention. The lines in the drawing, partly drawn with a ruler, reveal this as clearly as the awkward position of the model's limbs, some bent at an angle of precisely ninety degrees. The simple life and the simple forms appear to correspond, bringing them a fresh quality long vanished from city studios – as if the artist is using them to recreate an earlier life.

Mondrian's pastoral idylls produced in Winterswijk during 1898/99 were all in this vein. The paths and canals seem very straight, as in *Landscape with Ditch* (p. 8), while the farmer is ploughing incredibly elegant furrows (p. 10). The blue of the sky comes straight out of the paintbox, the roofs of the houses are bright red, and the farmer's wife in *On the Lappenbrink* (p. 6) is smiling openly, as if directly into the lens of a camera. At that period Mondrian appears to have been

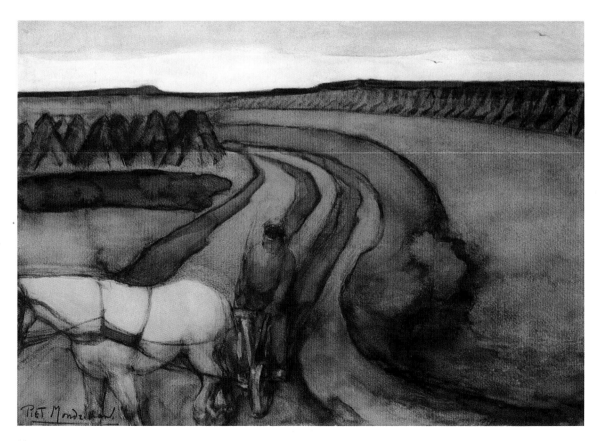

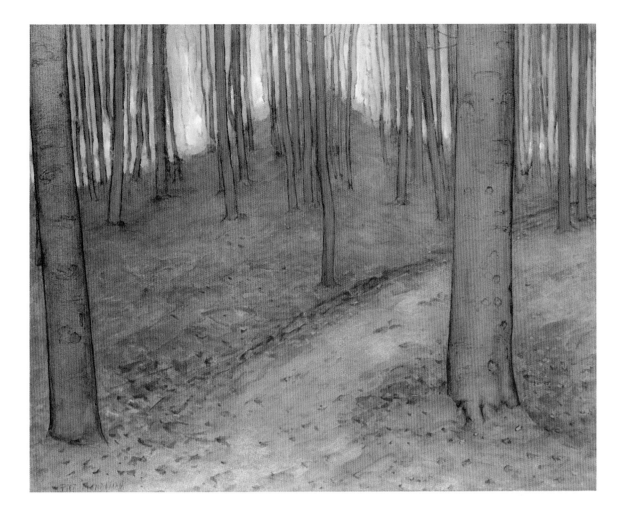

completely obsessed with the notion of portraying a motionless calm in nature. The clue to his preoccupation lies in the fact that the studio is the only setting where live action can be frozen until captured in paint.

A number of Netherlands artists were painting still poses at this time, but Mondrian is the only one whose work conveys such purity of mood without any trace of sadness. In distant Vienna, Gustav Klimt, the master of Art Nouveau, was producing landscapes remarkably similar to those of Mondrian (pp. 10 above, 11). What united Klimt, the master of erotic nude painting, and the young Dutch painter of pastoral idylls was their awareness of the artist's situation. Both could see that the future of painting no longer lay in the portrayal of life, but in the artificial atmosphere of the studio itself.

When the young Mondrian, with his father, used to create small devotional pictures by combining appealing figures and symbolic ornamentation, he was not concerned with making these compositions true to life. In 1900 Mondrian was still painting portraits of pretty little girls with flowers (cf. p. 13) which came very close to the kitsch of pictures in religious albums (p. 12 below, 20). But with his experience of producing such works, Mondrian found it easier than others to develop the new artificiality in painting.

Woods, 1898/1900
Boslandschap
Gouache, 45.5 x 57 cm
The Hague, Haags Gemeentemuseum

In his work around 1900 Mondrian concentrated chiefly upon landscapes. Their formal strength and atmospheric density link them to the works being produced around the same period by Art Nouveau artists in Germany and by the Vienna Modernists.

Portrait of a Girl with Flowers, 1900/01
Meisjesportret met bloemen
Oil on canvas, 53 x 44 cm
The Hague, Haags Gemeentemuseum

This portrait of an innocent, dreamy girl calls
to mind the highly symbolic, stereotyped
devotional images of about 1900. This is
hardly a coincidence, as Mondrian's father
designed commercial works of religious art
and had his son help him from an early age.

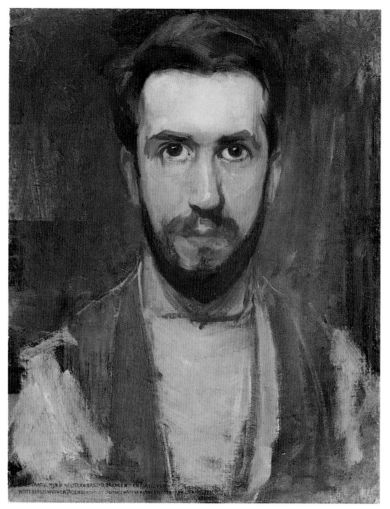

Self-Portrait, c. 1900
Zelfportret
Oil on canvas, mounted on stone,
50.4 x 39.7 cm
Washington D.C., The Phillips Collection

Mondrian's friend Albert van den Briel added
the following inscription at a later date:
"Herewith I venture to present myself to the
world and calmly await what is to be, since
fleeting destiny makes me yearn for certainty."

Devotional image, c. 1900
"Glory be to God!"
"Ere zij God!"

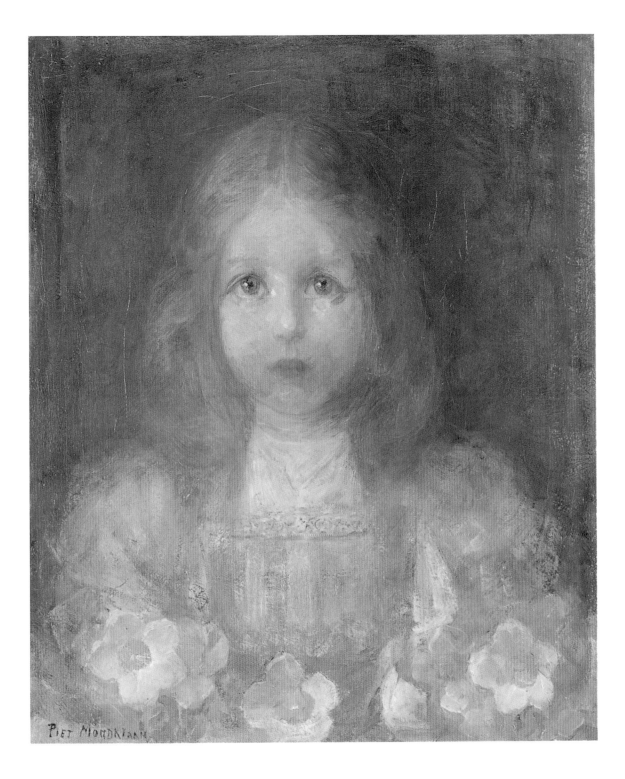

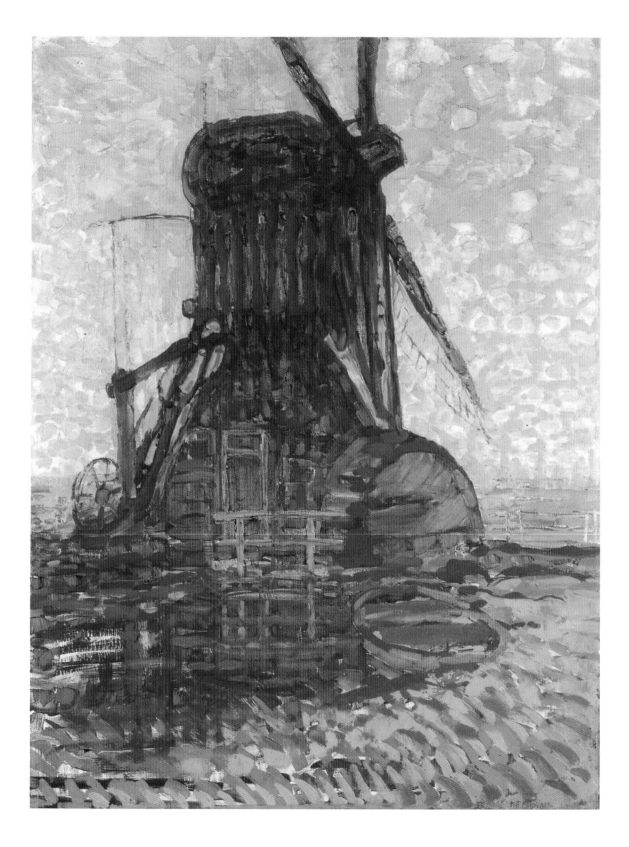

The Desire to Become a Great Painter

A photograph taken in 1905 shows Mondrian at work in his Amsterdam studio (p. 15). His hat hangs on the easel, as if he had just come in. With palette in hand and brush poised, he seems about to resume work on the half-finished still life set up on the easel. He scrutinises it, waiting for inspiration, but his outstretched foot suggests he is about to launch into action. Are we witnessing the moment at which a young genius is inspired by one of his progressive ideas?

The photograph is no random snapshot. Mondrian and his photographer arranged everything in the studio with the utmost care, including the artist's pose. They did so for a specific purpose – the intention was to present an image of Mondrian to the public and to reassure potential purchasers unsettled by modern experimentation as to his method of working. On the floor behind the easel are two small paintboxes of the kind used out of doors at that time. We can also make out oil sketches of a cow in a meadow and a mill in a landscape. The photograph is intended to show that Mondrian completed the final version of his paintings in the studio and that his subjects were exclusively scenes from nature that he would have been able to sketch out of doors. Around 1905 the majority of art lovers believed that this was the way the Old Masters had worked, and they, too, wished to buy only pictures that translated the experience of reality into harmonious forms.

By 1905 Mondrian had learned that the expectations of the public had to be taken into account, and the process of discovery had been hard. In 1898 and in 1901 he had entered for the Prix de Rome, the most prestigious art prize in the Netherlands, and had failed miserably. The jury, composed of the leading connoisseurs and artists in the country, remained entrenched in the conventions of academic painting, and rejected him on both occasions. They stated in their report that the young artist lacked talent for drawing and in particular that he was unable to portray lively action in a painting.

At this time Mondrian stood absolutely no chance of recognition as an artist and he could hardly sell any paintings. A whole catalogue of failures temporarily prompted him, between 1902 and 1903, to ally himself to those in active opposition to the establishment. He associated with the radical left, and is even alleged to have been involved in an "anarchist plot", as his best friend, Albert van den Briel, mistakenly termed it. In 1903 there was a major strike of railway workers in the Netherlands, ending in bloodshed. Mondrian always feared the potentially violent outcome of any public conflict. He therefore withdrew from politics at this point and in 1904 left the city. We know that a friend followed him all the way to Brabant in a vain attempt to bring him back. Mondrian now settled in the countryside and, burying himself in the isolation of the place, began painting pictures that took his work in a new direction.

He now turned to landscape painting in the traditional Dutch style. The secluded scenes in the middle of nowhere, the woodland, willow thickets and

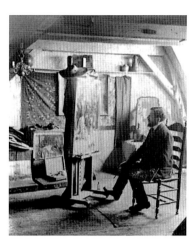

Piet Mondrian in his studio, 1905
Photograph
The Hague, Haags Gemeentemuseum

ILLUSTRATION PAGE 14:
Windmill in Sunlight, 1908
Molen bij zonlicht
Oil on canvas, 114 x 87 cm
The Hague, Haags Gemeentemuseum

After 1905 Mondrian returned to the familiar subjects of Dutch landscape painting. Ostensibly traditional themes thereby served as the vehicle through which he attempted to show that modern form and the use of pure colour were part both of the glorious past and, at the same time, of the future of art.

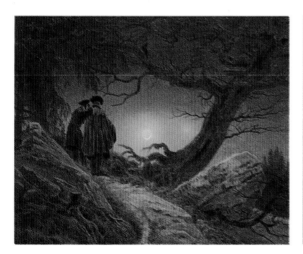

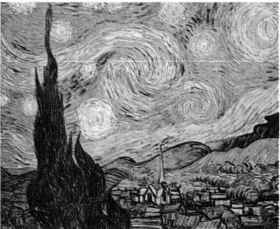

Caspar David Friedrich
Two Men Contemplating the
Moon, 1819/20
Zwei Männer in Betrachtung des Mondes
Oil on canvas, 35 x 44 cm
Dresden, Staatliche Kunstsammlungen

Vincent van Gogh
Starry Night, 1889
Oil on canvas, 73.7 x 92.1 cm
New York, The Museum of Modern Art
(Lillie P. Bless Bequest)

street corners which he had loved to paint, gradually disappeared from his repertoire. Instead he painted Brabant windmills or cows in pastures, subjects regarded as typical of Dutch painting to this day.

For the next few years sunsets, windmills (pp. 14, 27), moonlit nights (pp. 16, 17, 18), and views of the sea and the dunes (pp. 24, 25) were recurring subjects in Mondrian's pictures. He also began to produce flower paintings (pp. 20, 22, 23), still a little reminiscent of the floral illustrations typically accompanying Biblical quotations, so familiar to him from the trite imagery of Protestant art (p. 20). Mondrian knew exactly what the public liked. Later he wrote: "If the paying public demands naturalistic art, then an artist can use his skills to produce such pictures – but these are to be clearly distinguished from the artist's own art."

Meanwhile, what had happened to Mondrian's "own art" in all this time? The "paying public" was, in his judgment, responsible for a process, relatively rare in the history of painting, whereby an artist's development suddenly went into reverse and he produced paintings that were far less "modern" than those he had created previously.

From now onwards, Mondrian not only oriented himself towards the themes of the past, but also began copying the works of great artists. In about 1906 the art world began to show enthusiasm for van Gogh, who had died only a few years earlier. In 1907/08 Mondrian painted *Night Landscape* (p. 16 above). The shapes in the sky were unmistakably derived from the paintings of van Gogh. Van Gogh had used cloud formations apparently swirling in the sky to express the visionary quality of his experience of nature. In his *Starry Night* painted in Arles in 1889 (p. 16 below right), the coiling waves in the dark clouds suggest that the night sky appeared to him as a frenzied ocean, threatening to consume him.

ILLUSTRATION PAGE 16:
Night Landscape, c. 1907/08
Landschap bij nacht
Oil on canvas, 35 x 50.2 cm
Private collection

The countryside by night was a favourite subject for Mondrian. In *Night Landscape* he adopts formal motifs used by Vincent van Gogh, who had only just been discovered by the art world: the circular shapes that appear to be spinning in the sky indicate his desire to create pictures of a new artistic world of experience and not a direct experience of nature.

Summer Night, 1906/07
Zomernacht
Oil on canvas, 71 x 110.5 cm
The Hague, Haags Gemeentemuseum

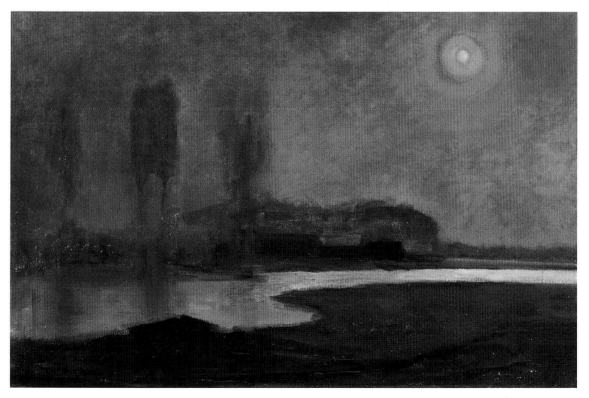

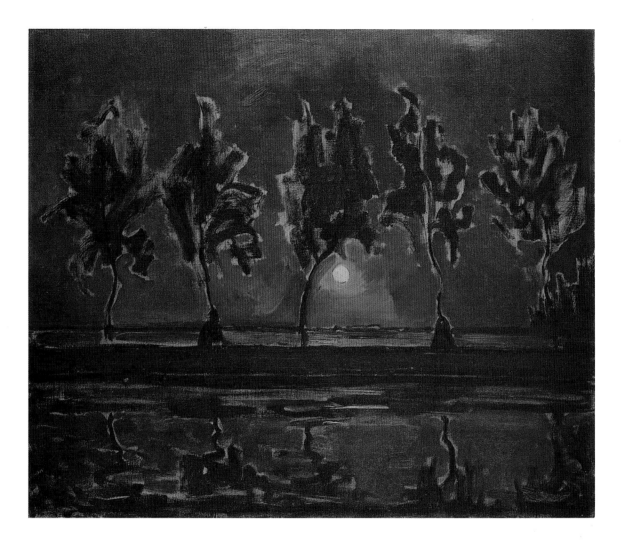

Trees by the Gein at Moonrise, 1907/08
Bomen aan het Gein bij opkomende maan
Oil on canvas, 79 x 92.5 cm
The Hague, Haags Gemeentemuseum

ILLUSTRATION PAGE 19 ABOVE:
Woods near Oele, 1908
Bos bij Oele
Oil on canvas, 128 x 158 cm
The Hague, Haags Gemeentemuseum

ILLUSTRATION PAGE 19 BELOW:
Caspar David Friedrich
Abbey in the Oak Wood, 1809/10 (Detail)
Abtei im Eichwald
Oil on canvas, 110.4 x 171 cm
Berlin, Staatliche Museen zu Berlin –
Preußischer Kulturbesitz, Nationalgalerie

The fact that Mondrian now adopted these forms in his own paintings may be seen as an expression of his wish to be an artist like van Gogh, living entirely in the world of his own perceptions. The echoes of van Gogh in *Night Landscape*, however, no longer portray Mondrian's experience of nature. They are much more a statement of his desire and will to become a great artist. This explains why this talented painter was prepared to go on producing pictures for so long in accordance with public taste – Mondrian actually wanted to be an artist with the ability to portray life as truthfully and beautifully as his predecessors. The only real difference between Mondrian's desires and those of the "paying public" lay in his own understanding: he knew that the times were past when artists were commissioned by noblemen, kings and wealthy citizens to record the whole world in pictorial form. In common with his "paying public", Mondrian longed for an art that was full of life and experience, and it was this longing that he brought to his paintings after 1905.

In the company of a friend, Mondrian would often visit those parts of the Netherlands with beautiful landscapes still unspoiled by industrialisation. He stayed in Brabant until 1905, spent the entire winter of 1906 in an old farmhouse idyllically set on the edge of woodlands, and throughout 1907 and

1908 he frequently returned to the vast heathland region near Otterlo. Before 1903 he had often painted the factories, ships, or dark apartment buildings of Amsterdam, but now he avoided these typical scenes of modern city life.

Mondrian particularly loved the countryside at night. His canvases seem to suggest that he spent many a summer night entirely alone with the calm, still waters reflecting the moon (pp. 17, 18). The German Romantic painters had been treating the same subjects a hundred years earlier. Mondrian now quite deliberately took up their pictorial themes. For example, Caspar David Friedrich's painting of 1819/20, *Two Men Contemplating the Moon* (p. 16 below left), shows two solitary wanderers looking at the night sky from a hillside. There is a glow in the background of the picture, but whether this is a realistic portrayal of the moon is doubtful. Blurred and mysterious, it is the focus of the painting. Mondrian shared the Romantics' uncertainty about the possibility of portraying nature in a picture. It made more sense to become absorbed in the immediacy of the painting itself, which could surely be every bit as mysterious as the actual experience of a moonlit night.

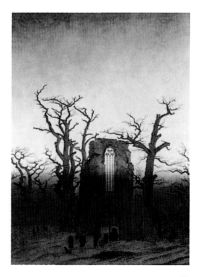

Mondrian recognised in the style of the German Romantics all his own ambivalence about painting. They too had had doubts as to whether art could

Chrysanthemum, c. 1908 (1921?)
Chrysant
Watercolour, 33.9 x 23.9 cm
New York, Sidney Janis Collection

Devotional image, c. 1900
"As for me and my house, we shall serve the
Lord."
"Aangaande mij en mijn huis wij zullen den
Heere dienen."

Passionflower, 1908 (?)
Passiebloem
Watercolour and ink on paper, 72.5 x 47.5 cm
The Hague, Haags Gemeentemuseum

The passionflower is traditionally a symbol for
the Passion of Christ. In Mondrian's
watercolour it springs from the shoulders of a
beautiful model, adorned like a saint.
Mondrian's flowers, originally derived from
the world of trite Protestant imagery, here
frame the myths of private life.

portray experience. In the final analysis was it simply a product of the studio? In
copying the Romantics, Mondrian came to a definitive decision on this issue –
paintings were merely references to other paintings. But in their uncompromising
stance against reality, pictures opened up a highly individual, enclosed and
mysterious world of experience. This discovery interested Mondrian so much
that he immediately abandoned all attempts to continue painting his Amsterdam
environment. He found the new world of copied landscape motifs far more
interesting. It seemed to offer a way into the consciously artificial new life in the
realm of art of which he had always dreamed.

The artificial character of the nature painting is instantly apparent in Mon-
drian's *Summer Night* (p. 17). The sky is particularly puzzling, with its flat
application of russet paint. No night sky ever looked like this. Mounted upon it
is the silvery-white moon, with its colour reflected in the water. The luminous
river reveals the clear traces of a broad brush rapidly drawn across the canvas,
leaving streaks of colour behind.

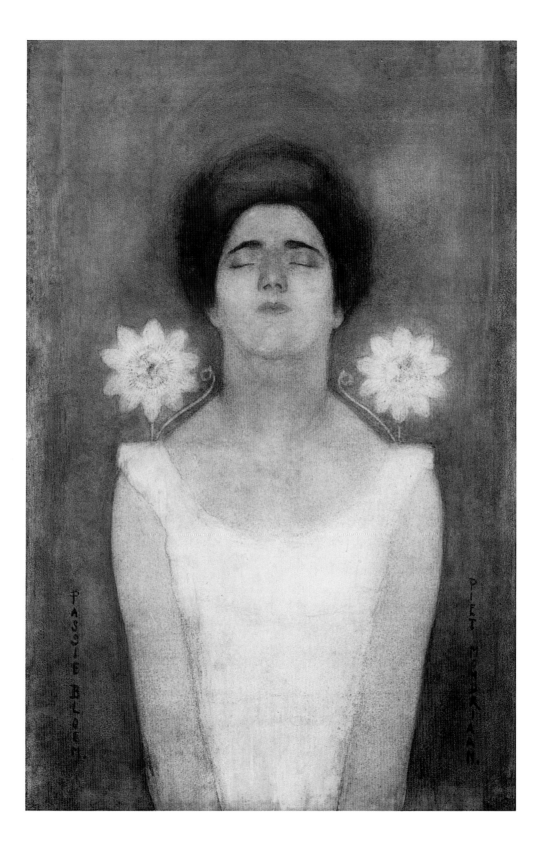

Chrysanthemum, 1908/10
Chrysant
Charcoal on paper, 36.4 x 24.8 cm
Amsterdam, private collection

Red Dahlia, 1907
Rode dahlia
Watercolour, 30.5 x 23 cm
New York, The Pierpont Morgan Library,
Daisy Shapiro Bequest

ILLUSTRATION PAGE 23:
Amaryllis, 1910
Watercolour over pen, 49.2 x 31.5 cm
Amsterdam, private collection

The paintings produced during 1906/07 are the first where Mondrian paints in the apparently careless and unprofessional manner which later became so typical of his work. The technician might comment that a little more solvent and less hasty brushwork could have produced a beautifully smooth river bank. But Mondrian, who had completed a thorough technical training at the Academy, was now quite deliberately forgetting what he had learned. These technical "mistakes" point to his overriding preoccupation from now on – experience of the painting itself.

As his output increased, Mondrian now surrendered with ever greater abandon to the intoxicating sensations unleashed in him by the brilliant colours on the canvas. The masterpiece of this period is *Woods near Oele* (p. 19). The entire painting seems to consist of elongated, in places serpentine lines of colour. Brilliant blue, yellow, violet and red paint runs down the canvas, occasionally in droplets, while the unpainted sections allow the material to show through. Mondrian also made a small and careful study in oils for this painting, completed on site in the woods. He was constantly at pains to demonstrate the close connection between his new experimentation with colour and traditional landscape painting. He wished to show that the sensation of colour could be just as overwhelming as the experience of tall woodland trees in sunlight.

Nevertheless, his attempts to merge the new with the traditional were unsuccessful. On closer inspection, *Woods near Oele* separates into two components – the coloured lines never actually come together to form the familiar outlines of a wood. Mondrian appears to have been aware of this unresolved contradiction and resorted to a long-established metaphor. In the final version of *Woods near Oele*, he changed the shapes of the trees that he had captured in his small oil study: they now curve inwards from either side around the disc of the sun, producing an outline reminiscent of a Gothic pointed arched window with a tracery rose.

The German Romantics frequently placed Gothic church ruins among trees in their compositions (compare for example p. 19 below). Light shining through windows which had once been painted by man was intended to be a reminder that the sun casting its brilliant light was God's creation. A picture, too, can only be seen in the light and by means of light – nature and art are both united in the process. In the enigmatic symbolism of the medieval window form set in the midst of nature, the problematic relationship between art and nature seemed to find reconciliation.

Mondrian used these old formulae to justify his own art, but made almost no effort to actually translate them into his pictures. Unlike even his admired predecessors, he did not attempt to make the primary colours in his paintings look like refracted light. Vincent van Gogh had devised a colour theory of his own for this purpose. Piet Mondrian, on the other hand, simply put together red, blue and yellow straight from the tube, as in his *Windmill in Sunlight* (p. 14). The rather crude application of colour creates an almost aggressive effect, and harsh splashes of colour leap out at the viewer. Unlike the earlier atmospheric, gentle landscapes in which Mondrian had frequently treated the motif of the mill, here he achieves a powerful, radiant composition. Just as van Gogh had made the radical move to expressive colour painting after his encounter with the French Impressionists, this innovation in Mondrian's work came as a result of his contact with French Neo-Impressionism and Fauvism.

It was pictures like these that brought Mondrian sudden fame in Holland in 1909. He was now seen as the exponent of the avant-garde and began selling paintings in large numbers. Success must have emboldened him to try and lead a conventional life and even to establish a family – he became engaged to Greet Heybroek that same year.

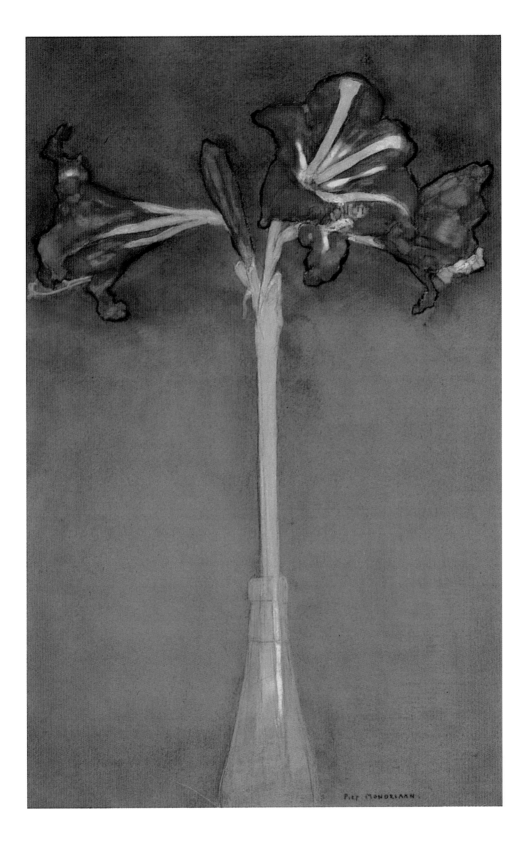

Dune Landscape, 1910/11
Duinlandschap
Oil on canvas, 141 x 239 cm
The Hague, Haags Gemeentemuseum

Mondrian's colourful landscapes rapidly
brought him fame in Holland. From 1909
onwards, when he spent the summer on the
North Sea coast of Zeeland, he produced a
large number of dune paintings and seascapes.
These paintings reveal a distinct development
over the course of time: the small, pointilliste
dune paintings of 1909 with their positive
colouring are succeeded by larger, far more
abstract compositions in 1910.

ILLUSTRATION PAGE 25:
Dune IV, 1909/10
Duin IV
Oil on card, 33 x 46 cm
The Hague, Haags Gemeentemuseum

The relationship soon foundered. In the very year of his success, a tragic event
occurred that threw Mondrian completely off course – in 1909 his mother died.
She was still fairly young and her death must have been unexpected. The
finality of this loss appears to have unleashed a virtually self-destructive
impulse in Mondrian. Within a very short time he lost the public support for
which he had fought so long.

The bright, joyful resonance, characterising the colour-splashed paintings
produced in 1909, during a long summer spent on the North Sea coast of
Zeeland, disappeared overnight. *Dune IV* (p. 25) probably dates from that
summer and is unquestionably a small masterpiece. There is a palpable feeling
of summer heat in the picture, echoing in the glow of its reddish-orange tones.
Pink hues emphasise the artificiality of the painting, but also conjure up an
association between the beautiful curves of the dune and the female form.

Mondrian later wrote that the spirit of woman was to be found in the
horizontal lines of the sea and the dunes. Strange as this assertion may sound,
the picture lends it conviction. The corporeal dunes appear as a portrayal of
erotic experiences, which mingle with the visual impressions of someone
strolling along the sunlit coast. In 1909 Mondrian had come very close to the
unity of experience and painting which he had sought so long.

In 1910 he began painting huge canvases in sombrely luminous colours.
Dune Landscape (p. 24) consists of angular broken forms and motionless
heaped shapes in dark, greenish-lilac tones. In the *Evolution* triptych (p. 29),
his major work of 1910/11, Mondrian tackled nude figures for the first time.
When these two paintings were exhibited in 1911 the response was intensely
critical. The new works were described as "cold and empty", and the artist
dubbed "a true brother", in disparaging reference to the affinity of the triptych's
subject matter with the doctrine of the Theosophical Society that Mondrian had
joined earlier in 1909.

The subject of the triptych is the genesis of the new as a result of the renunciation of sensual experience. Biological "evolution" is to be replaced by purely "spiritual" development. The ascent from the sphere of the flower nude, charged with sexual allusions, on the left panel to the cold, androgynous figure of light in the centre may be seen as an allegory of the "path from the body to the spirit". The citizens of Amsterdam would have recognised Mondrian's curious figures with firmly implanted emblems on their shoulders as borrowings from the world of Protestant imagery. The female figures of the triptych were based on male champions of God in the "Holy War" (p. 28). Mondrian's father had portrayed them in 1870 in one of his lithographs and, whilst still at home, the young Mondrian may have admired these chivalrous combatants.

In 1910, after the death of his mother, Mondrian was drawn back to his father's dogmas and dreamlike figures, which he clothed in towering female forms and in the colours of his own art. The significance of *Evolution* can only be explained in psychological terms, with Mondrian's interpretation of theosophical concepts of man and the cosmos expressed in a heavily symbolic form. But it also marked a new determination on the part of the artist to become what he already was – a painter, not of experience, but of cool, abstract form.

A year later, when Mondrian contributed to the first exhibition by the Moderne Kunstkring (Modern Art Circle), an Amsterdam-based society of artists, all his pictures expressed this new austerity. *Church near Domburg* (p. 26) and *The Red Mill* (p. 27) display the potential of this change far more

ILLUSTRATION PAGE 26:
Church near Domburg, 1910/11
Kerk te Domburg
Oil on canvas, 114 x 75 cm
The Hague, Haags Gemeentemuseum

ILLUSTRATION PAGE 27:
The Red Mill, 1910/11
De rode molen
Oil on canvas, 150 x 86 cm
The Hague, Haags Gemeentemuseum

Both pictures were shown in Amsterdam at the Moderne Kunstkring exhibition of 1911. The clear, simple outlines and colours give the paintings their monumentality.

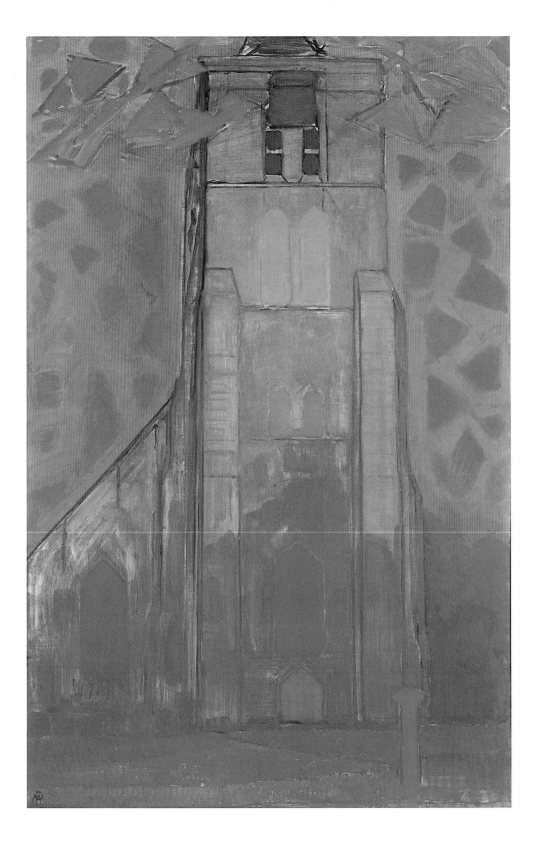

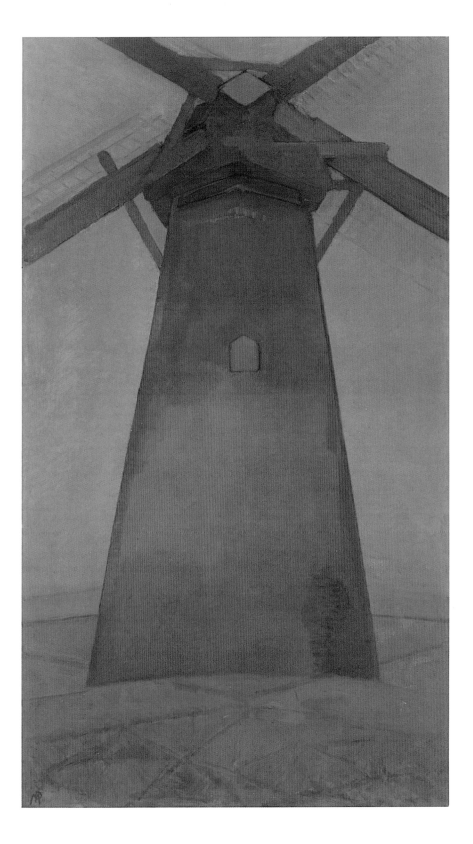

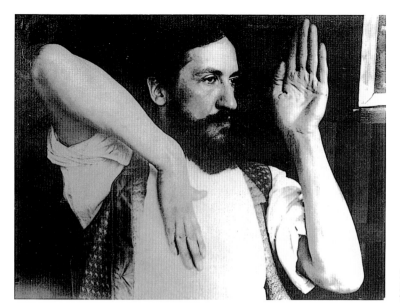

Mondrian meditating, 1909
Photograph
The Hague, Haags Gemeentemuseum

clearly. *The Red Mill* confronts the viewer with a towering wall of colour of cold intensity, overwhelming in its distanced monumentality. With one grand gesture Mondrian seems to be bidding farewell to his public support. The series of monumental blue paintings, more than ten metres wide overall, which he exhibited in Amsterdam in 1911, would not fit in any of his purchasers' drawing rooms. The self-assurance emanating from these works is such that they might have been ordered by some unknown sovereign for his castle in the clouds.

At the end of 1911 Mondrian decided to leave Amsterdam and moved to Paris, where he now wished to learn from the man whom he had recognised as the greatest painter of his age – Pablo Picasso.

H.C. Selous
The Captains of El Shaddai, c. 1860
(Detail)
Illustration in Johannes Bunyan, *De Heilige Oorlog*, Amsterdam 1881

28

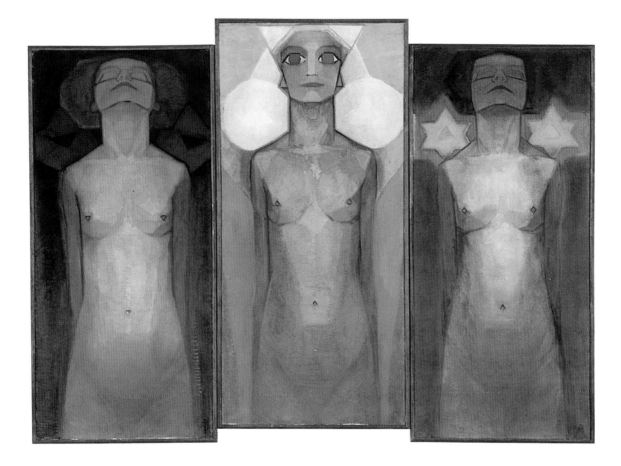

Evolution, 1910/11
Evolutie
Oil on canvas, 178 x 85 cm, 183 x 87.5 cm, 178 x 85 cm
The Hague, Haags Gemeentemuseum

"Evolution" means the gradual development of living matter from lower to
higher forms. Like many of his contemporaries, Mondrian sought to
replace Darwin's theory with a concept of spiritual, intellectual
development. To this end he drew upon theosophical concepts of man and
the cosmos and upon traditional Christian imagery. The abstract elements
in the figures show that Mondrian wanted abstract art to play a significant
role in the "spiritual" evolution of history. The monumental tryptic is a
programmatic painting. It was not well received in the art world and critics
described it as "cold and empty".

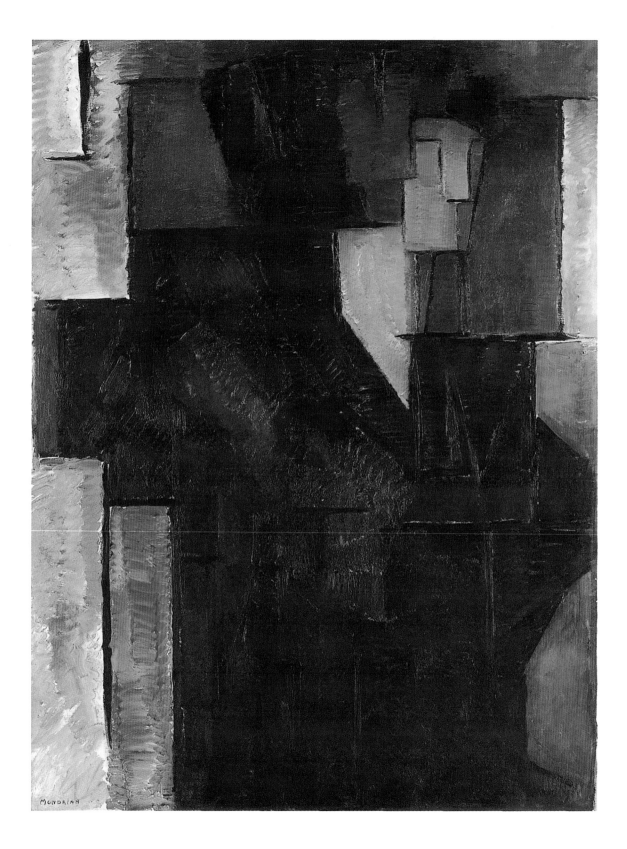

The Move to Paris – Catching up with Modern Art

Mondrian was just approaching his fortieth birthday when he left for Paris. The move marked the end of a highly restless, prolonged youth. In 1910, while still in Holland, Mondrian had written to a friend: "Loneliness enables a great man to recognise the true person within himself, the God-like, and indeed God. And thus one grows (…) and eventually becomes God oneself." The blue infinity and vast sombre expanses of his paintings dating from that year appear to portray the extreme state of mind of an artist who was utterly self-absorbed, both in his artistic as well as his personal life. In Paris Mondrian at last succeeded in finding himself, his art and a way of life that suited him perfectly. Immediately after arriving in Paris, he heralded this new beginning by discarding his father's name, Pieter Cornelis Mondriaan, and from then on called himself Piet Mondrian.

In October 1911 the artist had seen works by Georges Braque (cf. p. 32) in Amsterdam. The sight of them must have been a revelation, as they dated from 1908 and resembled his own output from the same period in many details. At that time Braque had a preference for oval-shaped views framed by the branches of old trees. Mondrian, too, had introduced the same oval shapes formed by two or three curving lines and made them a leitmotif of his paintings, one which can be seen in modified form in almost all the landscapes of this period. It appears in the motif of the sun framed by trees in *Woods near Oele* (p. 19), for example, and between the horizontal banding of the dunescapes of 1909. *Trees by the Gein at Moonrise* (p. 18) also offers a similar view. For Mondrian, it seems, this oval form signalled the presence of his own personal visual experience within the painting, as he used it repeatedly in very different landscapes. It represented a kind of visual signature. He now saw that Braque was also obsessed by this form. Was there, then, someone in Paris who saw with the same eyes as he did, and consequently had the same ideas about painting as himself?

The move to Paris at the end of 1911 may have helped Mondrian escape from his sense of cosmic isolation. When he first arrived he knew no one in Paris, and he made no attempt to meet Picasso and Braque. The mere fact that they were living and working in the same city, and that he had the opportunity to see their paintings there, was enough for him. He began to contribute towards the "revolution" already begun by other kindred spirits in the field of avant-garde art. This work in the unfamiliar setting of the big city replaced the kind of commissions awarded to artists in earlier times by the bourgeoisie and royalty. Large formats, and the language of pure, "celestial" colours as a metaphor of the "divine artist", provisionally disappeared from his work, and Mondrian avoided using his brilliant blue, yellow and red for some considerable time. He now returned to working in detail.

The colour scale of his first Paris paintings is limited to grey, brown and black, corresponding to the palette of Picasso and Braque. The two Cubist artists did not need colour at that time. They were in the process of analysing the

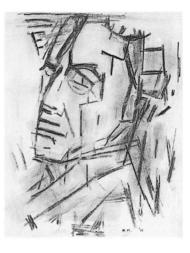

Self-Portrait, 1912/13
Zelfportret
Charcoal on paper, 28 x 23 cm
New York, Sidney Janis Collection

ILLUSTRATION PAGE 30:
Study of a Figure, 1911
Figuurstudie
Oil on canvas, 115 x 88 cm
The Hague, Haags Gemeentemuseum

This portrait of a woman merges mysteriously into the dark surface. Mondrian's confidence in the expressiveness of the pictorial surface is evident in this painting, which dates from the very beginning of his time in Paris. In 1944 Mondrian described his life as an artist in Paris from 1912 onwards in terms of martyrdom to Modern Art, recalling the Christian martyrs and religious revivalists he had portrayed in an early series of illustrations in 1896/97.

31

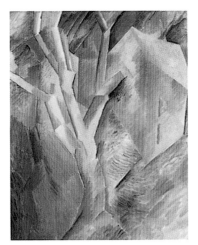

Georges Braque
Houses and Trees, 1909
Maisons et arbres
Oil on canvas, 64.5 x 54 cm
Sydney, Art Gallery of New South Wales

In 1911 Mondrian moved to Paris, after seeing paintings by Braque that resembled his own.

Pablo Picasso
Standing Female Nude, 1910
Femme nue debout
Charcoal on paper, 48.3 x 31.2 cm
New York, The Metropolitan Museum of Art

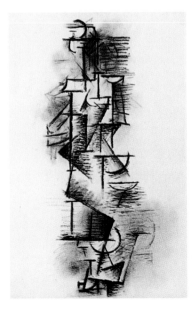

fundamental elements of classical painting and claimed that drawing had been more important in the history of painting than colour. Drawing alone could fuse the various colours on the canvas into a picture. They therefore decided that, for the purposes of a modern art which was no longer to represent the colourful naturalistic world, only the drawn line was to be used.

Picasso and Braque invented a fundamental element of two black lines, which now formed the basis of all their paintings. Braque, the more playful and dreamy of the two, loved to scatter these black lines across the canvas, like a regular pattern. But for Picasso the lines used by the artist were intended as a basic framework of the visible world. In his drawing *Standing Female Nude* of 1910 (p. 32), these lines form a kind of skeleton, and the shapes suggesting the skin and body of the female form seem to be suspended on its jagged outline.

Mondrian instantly understood the potential of this idea. Since 1912 he had been using black lines like a grid lying on the surface of the picture; in his *Landscape with Trees* of 1911/12 (p. 33), for example, the individual shapes are enclosed like leaded glass. In Mondrian's case, the lines become the basic framework of the painting. The surface is marked out by the network of black lines. The artist inserts his shapes between the lines, as if he were writing on the surface.

The difference between Mondrian and the French artists he admired is clearest in their treatment of the portrait and the nude. Picasso would often say that the artist should dominate nature and women. His drawings demonstrate his virtuosity in arbitrarily taking apart or reassembling the image of a woman.

In Mondrian's *Study of a Figure* (p. 30), which probably dates from the very beginning of his time in Paris, the female figure appears to merge into the darkness of the surface. She seems to be gripped on all sides by the network of lines extending over the surface. Some of her feminine curves are still recognisable, whereas others have already become as angular as the edges of the linear grid. Mondrian noted at the time: "Woman is opposed to art and opposed to abstraction – in her innermost being. (…) An artist is at once both man and woman and consequently has no need of a woman." When Mondrian sets a female figure at the centre of his painting it may be that he believes that in this way he can comprehend the essence of femininity and virtually possess it through his work. This idea would seem to come close to Picasso's notion of the mastery of nature and women. However, Mondrian attributed even more to the painting – for him it embraced the life of the imagination which he wished to inhabit, just as he lived in the foreign city of Paris, the city of his dreams.

From now on, the network of black lines was to perform the same function in his painting as the oval had done earlier. The black lines became the symbol of his own entirely individual way of seeing things. In the course of 1912 he succeeded in merging the linear network into his paintings of nature. He discovered the motif of the tree. Its tangle of branches resembled the black lines on the surface of the picture.

In his painting of 1912 entitled *The Grey Tree* (p. 35) he tried to convey the mass of foliage and the misty grey air in an apple orchard. *The Grey Tree* has a clear linear structure and yet conjures up atmospherically the sight and smell of a real orchard.

In *Apple Tree in Flower* (p. 34) painted in the same year, the layers of colour are more transparent. The location of the tree becomes incidental. The pictorial structure now appears to develop from the centre in the way that fruit develops from the blossom on a tree.

Trees in Blossom (p. 35) is even more abstract in concept and more clearly defined. It would be difficult to distinguish between the white of the apple blossom and the white surface of the picture, with its curving black lines. The

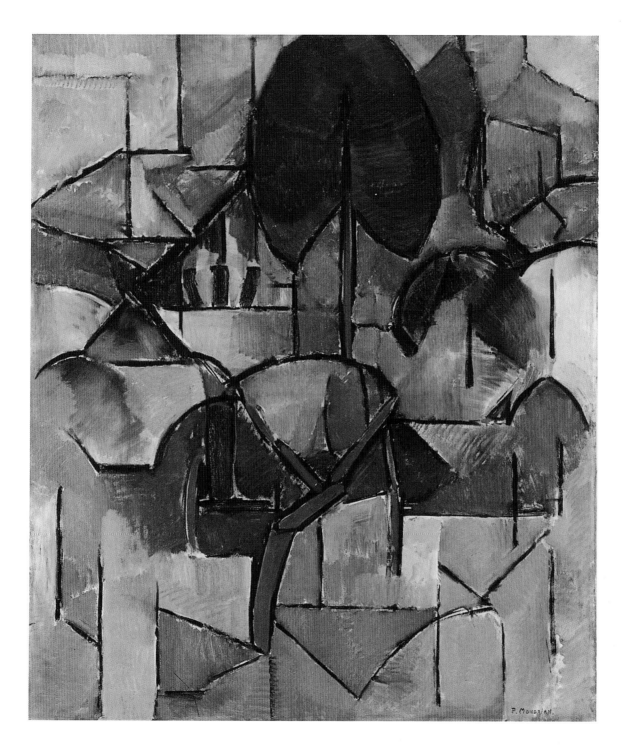

Landscape with Trees, 1911/12
Landschap met bomen
Oil on canvas, 120 x 100 cm
The Hague, Haags Gemeentemuseum

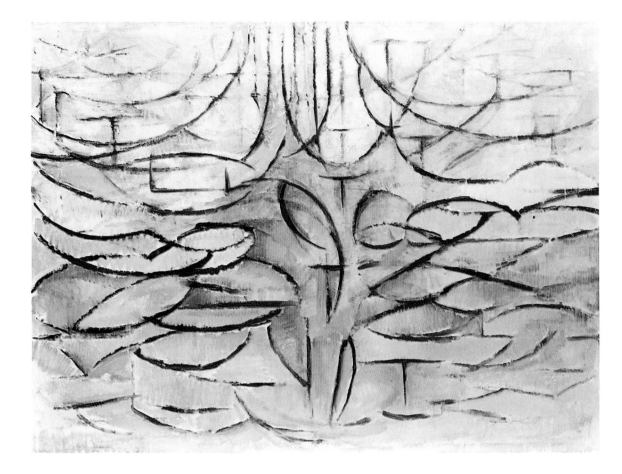

Apple Tree in Flower, 1912
Bloeiende appelboom
Oil on canvas, 78 x 106 cm
The Hague, Haags Gemeentemuseum

Of all places, Mondrian chose the built-up city of Paris to paint apple trees in flower. An abstract network of black lines is intended to portray nature and landscape, as a metaphor for the convergence of the pictorial surface with the external world.

natural forms here resemble the linear network constructed by the artist. This picture seems to preserve something of the impression of real, blossoming trees: on moving through an orchard it is easy to lose the overall prospect, as the view is barred on all sides by the whitish-pink laden branches.

Mondrian's *Trees in Blossom* and *Composition Trees II* (p. 36) both present similar difficulties in orientation. The eye searches for the motif and sees a surface covered with shapes that are in part quite evenly distributed. The linear network coloured with a patchwork of white and light grey extends right up to the edge of the picture and seems to want to spill out beyond it.

In 1913 Mondrian discovered that the jumble of houses in the city was ideally suited as a means of inscribing everyday events into the linear network of Cubist paintings. A sketch dating from 1913/14 (p. 38) shows the surface covered with broken lines and then overlaid with a few larger areas. *Tableau III* (p. 39) of 1914 has these areas painted in colour – brick-red, grey and sky blue – the colours of the city. A few window cross-pieces and arched doorways seem to emerge from the puzzle of shapes.

At that time Mondrian had a studio in the rue du Départ near the Gare Montparnasse. There were a few vacant building lots nearby, and the division walls of the neighbouring houses were thus exposed. Affixed to them were posters and the remains of coloured wallpaper from the demolished houses (p. 45). Mondrian loved these walls. They were just like huge abstract pictures. Standing in front of them, it was easy to conclude that modern painting was not

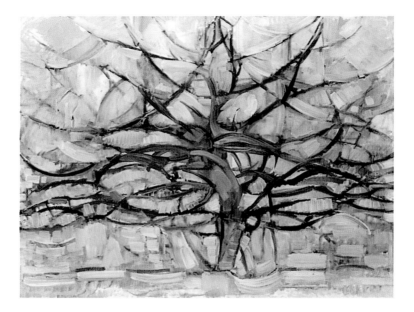

The Grey Tree, 1912
De grijze boom
Oil on canvas, 78.5 x 107.5 cm
The Hague, Haags Gemeentemuseum

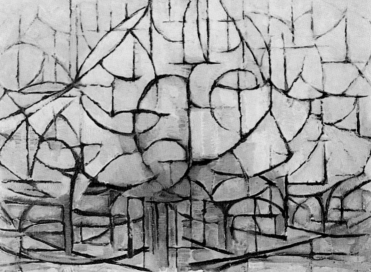

Trees in Blossom, 1912
Bloeiende bomen
Oil on canvas, 65 x 75 cm
New York, The Judith Rothschild Foundation

Cubism had created a uniform, flat and
evenly patterned pictorial structure, which
particularly interested Mondrian.

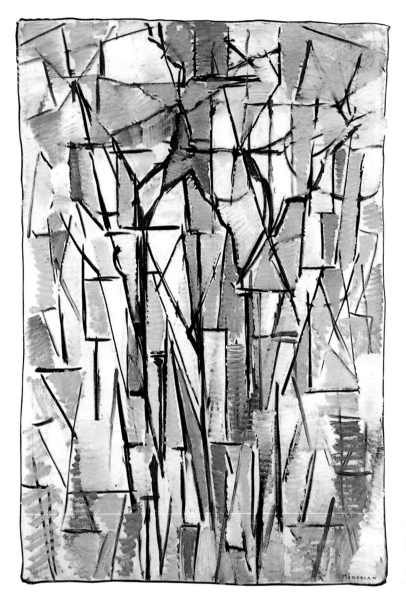

Composition Trees II, 1912
Compositie bomen II
Oil on canvas, 98 x 65 cm
The Hague, Haags Gemeentemuseum

Some of Mondrian's landscape paintings are like stained-glass windows: the black lines enclose the shapes in the same way that leading holds the flat pieces of coloured glass in place. Is this abstract network of black lines an attempt to reconcile nature and art in the traditional image of the church window?

really abstract at all. On the contrary, it was an entry into areas of reality hitherto unknown and disregarded.

Mondrian portrayed the beauty of a division wall in *Blue Façade* (1913/14; p. 42). He painstakingly prepared the picture in the manner of the Old Masters and noted the colours of the wall and the fragments of wallpaper in a preliminary sketch. The painting is full of Cubist black lines which break up the motif in a playful fashion. Mondrian scaled the composition in such a way as to make the wall and painting appear to become one.

In 1914 Mondrian still desired to become a painter comparable to Rembrandt. He turned back to the great themes of classical landscape painting and saw that some were more appropriate to his new style of painting than the Parisian sea of houses. Nature could be regular and could repeat itself. The monotone Dutch coastal landscapes were a prime example of this. Mondrian painted the sea with

ILLUSTRATION PAGE 37 ABOVE:
Still Life with Ginger Jar I, 1911/12
Stilleven met gemberpot I
Oil on canvas, 65.5 x 75 cm
The Hague, Haags Gemeentemuseum

ILLUSTRATION PAGE 37 BELOW:
Still Life with Ginger Jar II, 1911/12
Stilleven met gemberpot II
Oil on canvas, 91.5 x 120 cm
The Hague, Haags Gemeentemuseum

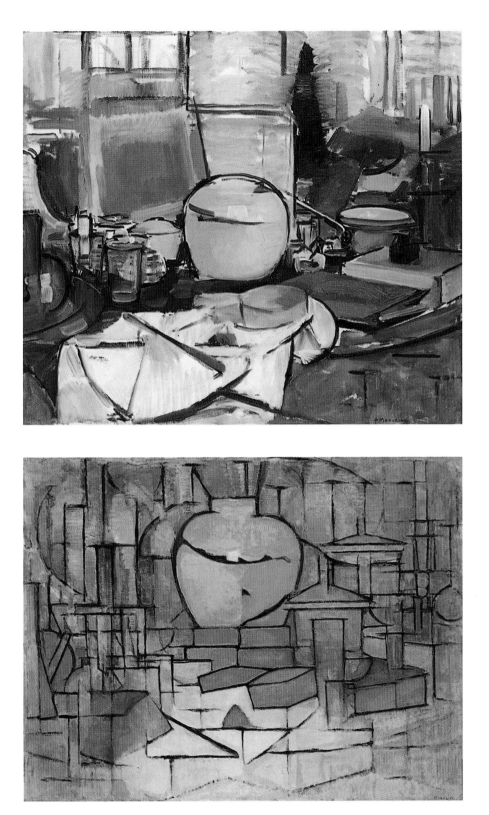

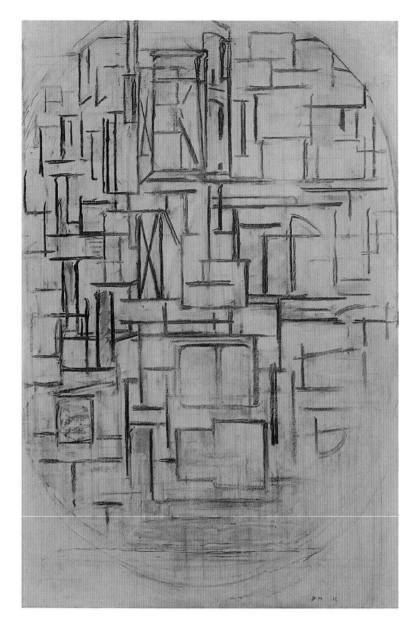

Oval Composition, 1913/14
Ovale compositie
Charcoal on paper, 152.5 x 100 cm
Venice, Peggy Guggenheim Collection

In Paris Mondrian inscribes uniform
landscapes into the linear network of his
pictures – the sea, starry sky and the view
across the rooftops of Paris. This drawing
shows the stonework and inscriptions on the
façade of a demolished house.

ILLUSTRATION PAGE 39:
Tableau III, 1914
Oil on canvas, 140 x 101 cm
Amsterdam, Stedelijk Museum

House façades are the subject of this
composition. The city colours are the clue to
identifying the subject of the painting within
the abstract linear network.

horizontal reflections of light playing on the crests of parallel waves. In *Composition No. 10 (Pier and Ocean)* (p. 43) he simply used the basic Cubist elements with their criss-crossing lines and arranged them in an oval shape, instantly suggesting the curve of the horizon.

The pictorial form that Mondrian had evolved at that time, with its abstract symbols evenly distributed right across the canvas, represented a tremendous innovation in the history of art. Hitherto paintings had always had a recognisable centre, an upper and lower section and a motif. The artists' craft lay in the composition, in endeavouring to create a harmonious balance between the different forms on the left and right and the upper and lower parts of the picture and to establish an order within the whole. Now, however, Mondrian abandoned

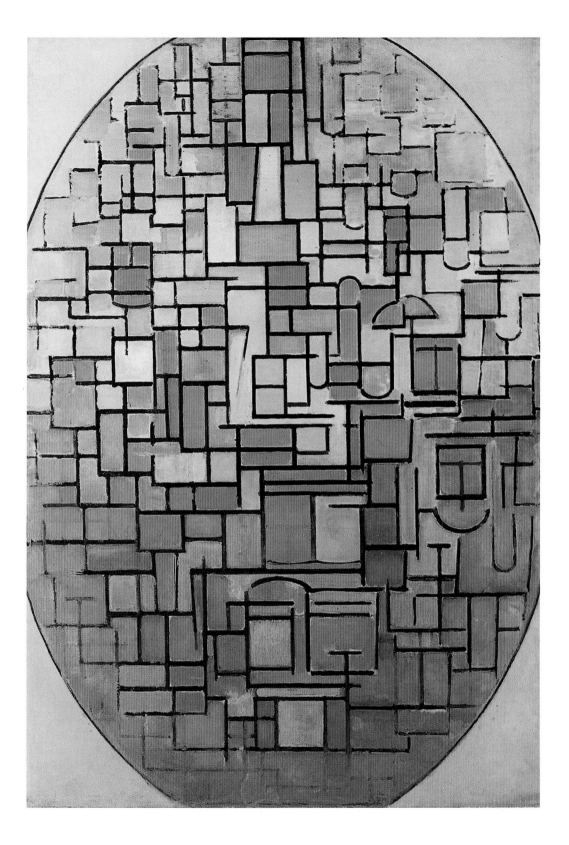

Church at Domburg, c. 1914
Kerk te Domburg
Ink on paper, 63 x 50 cm
The Hague, Haags Gemeentemuseum

Robert Delaunay
***Simultaneous Windows on the City
(1st part, 2nd motif)***, 1912
Les Fenêtres Simultanées sur la Ville
(Ière partie, 2e motif)
Oil on card, 39 x 29.6 cm
Paris, Eric et Jean-Louis Delaunay Collection

order. He scattered his forms almost casually across the entire surface, and these forms were all alike.

There must then have come a point when he realised what he had achieved. Everything now seemed possible – he could throw completely abstract grids across the white surface or he could make familiar scenes from his home landscapes emerge from the linear system (pp. 40, 41). The pictures he was painting now did not reproduce nature, yet appeared every bit as inaccessible and unfathomable, as empty and magnificent as the countryside, the sea or the starlit sky.

A number of Parisian artists before him had attempted to create paintings giving an impression of a view of the infinite. Among them was Robert Delaunay with his series of *Window Pictures*, the *Fenêtres Simultanées* (cf. p. 40), which Mondrian must have known. By contrast with Delaunay's variety of form and colour, Mondrian used the full range of potential in Cubism for expressing uniformity and emptiness.

ILLUSTRATION PAGE 41:
Composition No. 6, 1914
Compositie nr. 6
Oil on canvas, 88 x 61 cm
The Hague, Haags Gemeentemuseum

ILLUSTRATION PAGE 42:
Composition No. 9, Blue Façade, 1913/14
Compositie nr. 9, Blue Façade
Oil on canvas, 95.2 x 67.6 cm
Basle, Ernst Beyeler Collection

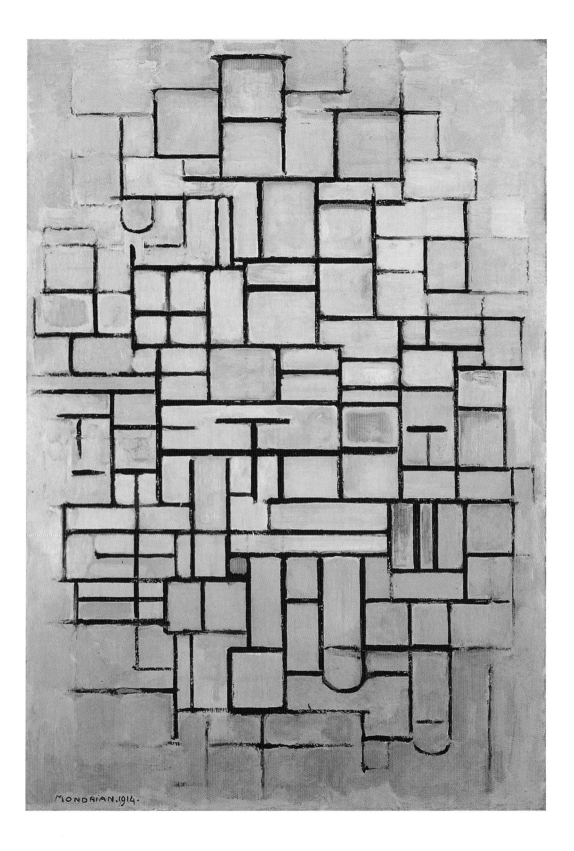

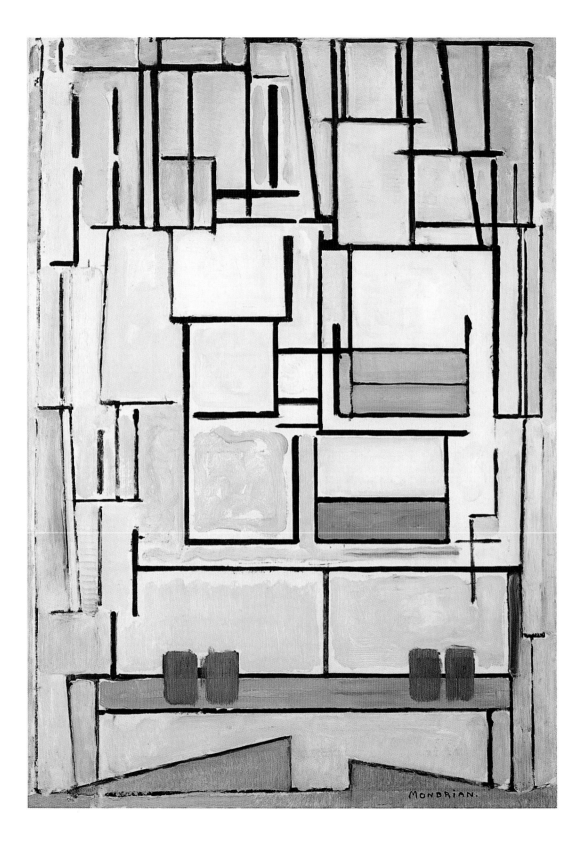

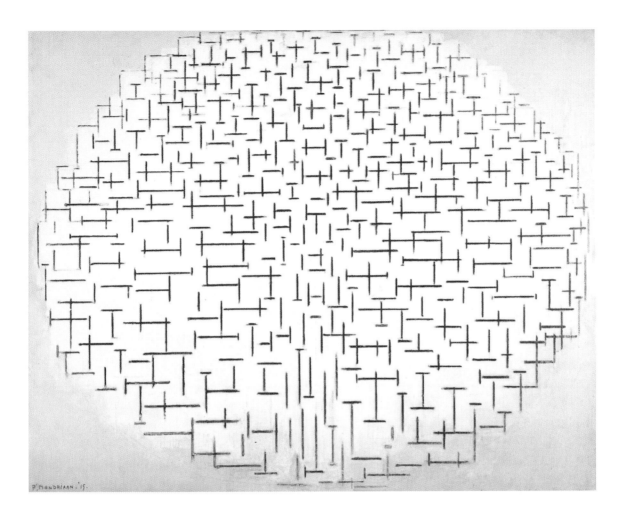

Composition No. 10 (Pier and Ocean), 1915
Compositie nr. 10 (Pier en oceaan)
Oil on canvas, 85 x 108 cm
Otterlo, Rijksmuseum Kröller-Müller

In this painting the portrayal of nature is reduced to an abstract pattern of
lines. Dispersed evenly over the surface of the picture these lines may
allude to the rhythmic motion of sea waves. The compression of the linear
network towards the top of the picture vaguely indicates a horizon, while
the dominance of vertical lines in the lower centre of the composition
suggests a jetty projecting into the sea. However, in contemporary
documentation this picture is also referred to as "Starlit Night" and even
"Christmas Eve". There was an intuitive understanding at the time that
the new openness of the abstract linear network could lend itself to a
variety of interpretations.

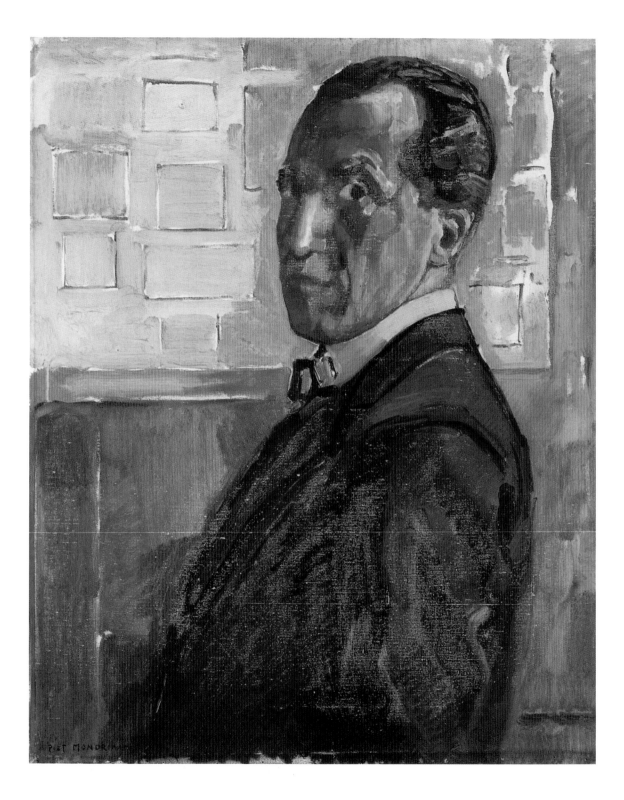

Victory over Picasso – and afterwards

Why Mondrian should have left Paris in the summer of 1914, just as the political crisis was coming to a head, is not known for sure. He probably wanted to return to Holland to visit his sick father. The outbreak of war compelled him to remain in his home country for several years.

His artistic output dropped considerably. This may have been because his new paintings were so pared down to basic essentials that a single one of them seemed to suffice. Why therefore continue to paint abstract black lines on white surfaces? It is quite likely that at this time Mondrian began searching beyond the studio for a justification for his paintings.

For the first time in his life, Mondrian took an interest in society. He bought himself a dinner jacket and drew and painted himself wearing it in front of a mirror (p. 44). He sought out and made friends in the smart circles of Amsterdam society. He made a great point of addressing them by their titles in regular letters containing information about his art. The art historian H.P. Bremmer, who advised the Kröller-Müllers, a rich family of industrialists, on their patronage of artists, soon started to pay Mondrian an annuity, in order to secure Mondrian's most important paintings for the collection under his direction. Mondrian even managed to win over the critics, although they could find little to say about his paintings. They were more interested in writing about Mondrian himself and his ideas.

During his time in Paris Mondrian had sometimes recorded his thoughts on art theory in his sketch book and he now began to harbour greater literary ambitions. His time was taken up with assembling ideas and expressing them in words. He moved to Laren, an artists' colony going back to the 19th century, where he showed himself extremely interested in the life and thought of the avant-garde theorists and artists of the place. He was never without his notebook, which he would bring out even in company, in order to record what he heard as well as noting his own contributions to the discussions.

He soon became acquainted with Theo van Doesburg, the painter and poet from Leyden. Van Doesburg was well-versed in art theory and also had a thorough knowledge of the German philosophical tradition since Kant and Hegel. Once Mondrian had shared his own knowledge of the latest developments in French art with him, the two became inseparable. Van Doesburg soon began to paint in the style of Mondrian, while Mondrian set to work writing a major treatise on avant-garde painting, for which he kept coming to his friend for advice. The two succeeded in assembling around them a circle of the best young artists, architects and designers in the Netherlands. Theo van Doesburg launched a magazine, which appeared from 1917 onwards under the title *De Stijl*. In addition to his own essays and those of Mondrian, it contained texts and designs by people such as the furniture designer and architect Gerrit Rietveld (cf. p 54). *De Stijl* sought to establish a new unity of all the arts. They were all to work

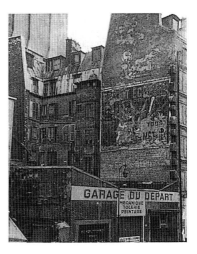

Paris, corner of Boulevard Edgar Quinet and rue du Départ
Photograph

ILLUSTRATION PAGE 44:
Self-Portrait, 1918
Zelfportret
Oil on canvas, 88 x 71 cm
The Hague, Haags Gemeentemuseum

In 1918 Mondrian painted an almost naturalistic self-portrait showing, in the background, an abstract painting in the style of 1917. The Old Masters had portrayed themselves in a similar pose including examples of their own work in the picture.

Pablo Picasso
Still Life in front of a Window in St. Raphael, 1919
Nature morte devant une fenêtre à Saint-Raphaël
Gouache and pencil on paper,
35.5 x 24.8 cm
Geneva, Heinz Berggruen Collection

Following Picasso's example, Mondrian attempts to set a stage for his paintings, the result of a free choice of style.

ILLUSTRATION PAGE 47:
Composition, 1916
Compositie
Oil on canvas, 119 x 75.1 cm
New York, The Solomon R. Guggenheim Museum

together to shape the modern world, and were indeed already doing so. In accordance with Mondrian's ideas, van Doesburg propounded the theory that henceforth in art "nature and intellect, or the feminine and masculine principle, the negative and the positive, the static and the dynamic, the horizontal and the vertical" should be brought into equilibrium.

The group of artists that formed around Mondrian must have reminded him of the autonomous groupings from his Protestant Church days. He was the only one who did not contribute designs for architecture to be decorated in the new style. However, he became arguably the most important and productive theorist of the circle. His writings for *De Stijl* were essentially theological, even though the name of God no longer appeared. A whole range of lofty ideals had been substituted – the "essence" of the world, the "substance" of all things, the "spirit", the "future" of mankind and the "inner", mankind's psyche and profoundest desires.

In 1916 Mondrian produced only one abstract painting – *Composition* (p. 47). Mondrian's small drawings show that the linear grid with its reddish, yellowish-brown and blue patches evolved from the façade of the stone tower in his *Church near Domburg* (p. 26), rising up against a blue sky. He liked to compare himself with the medieval cathedral builders, and wrote to Theo van Doesburg that he had used the theme of the church façade to express the "idea of ascending", just as they had done.

With the best will in the world, it is not possible to detect the church façade in *Composition*, yet the concept of "ascent" is recognisable. At the upper edge of the painting the black lines converge, while the forms seem to be detaching themselves from the lower edge and moving upwards. There is a pink square at the centre of the picture, to which four black lines have attached themselves – seemingly almost temporarily, as if they were merely swimming past in the field of blue. The entire picture consists of such lines and of patches of colour in the three primary colours, that have hooked onto the lines to form small structures. It is possible to imagine the small abstract motif moving to the right: all four black lines suggest a rotary movement. If it were to move, however, then the whole picture could change its shape as well. It seems as if the picture is still in motion and has not yet established its definitive form from the lines of the drawing, which give the colours their shape, and from the mingling of the primary colours, representing the hues of nature.

In 1916 Mondrian again attempted to make the process of evolution of form the subject of an abstract painting. It was no longer meant to appear to result from natural processes, as in the Tree pictures of 1912. The search for meaning and form was now transferred in the imagination to society as a whole. The concept underlying Mondrian's paintings – namely to appear as never completed works – was the same as that of the cathedral.

In order to be able to create this illusion, it was important to leave scope for the imagination within the picture. 1917 saw the production of white paintings, in which there is nothing to be seen apart from some free-floating coloured squares and black lines on a white background, as for example *Composition in Colour A* (p. 48). Among Mondrian's most beautiful paintings are his *Compositions with Colour Planes* (e.g. p. 49), where the black lines have been omitted and pastel-coloured rectangles seemingly drift about in gentle rhythm against the white background. He wrote to Theo van Doesburg that these pictures were inextricably linked to the position in the studio where they had been painted, and that they reflected the light of just one particular day.

During these years Mondrian and van Doesburg both agreed that avant-garde painting had to be closely allied to an equally radical modern architecture. Clear colours in combination with simple white structural elements were to take the

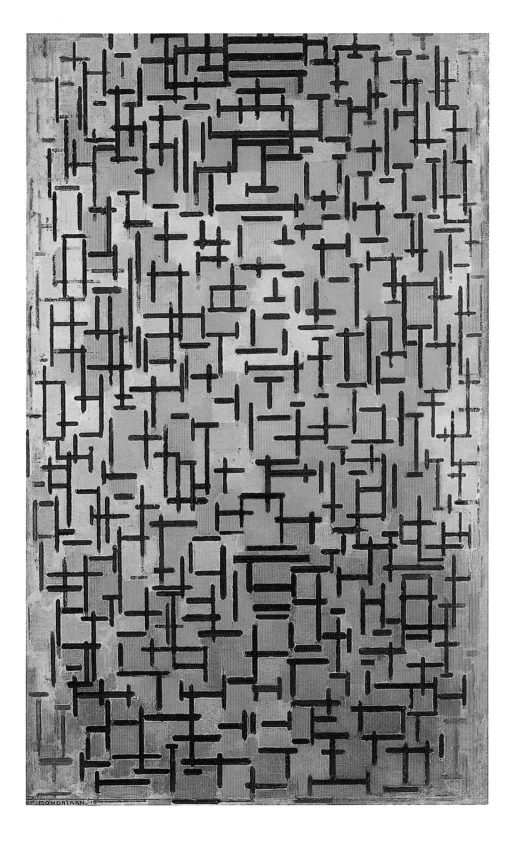

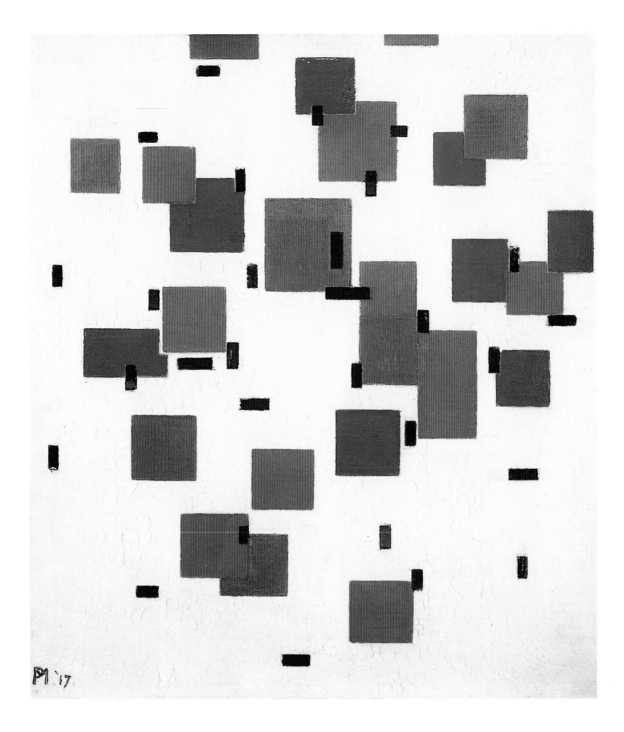

Composition in Colour A, 1917
Compositie in kleur A
Oil on canvas, 50 x 44 cm
Otterlo, Rijksmuseum Kröller-Müller

Composition with Colour Planes No. 3, 1917
Compositie met kleurvlakjes nr. 3
Oil on canvas, 48 x 61 cm
The Hague, Haags Gemeentemuseum

In this picture Mondrian omits the network of
black lines for the first time. It only appears in
negative, in the angular definition of the colour
planes. The colour planes are rhythmically
arranged against the white background and
appear as if in motion. Without the linear grid,
the painting gives the effect of being a detail
taken from a free composition of colour
elements in an imaginary space.

place of the sad and stuffy world of the 19th century, which they liked to refer to
as "brown". Once this new architecture was established, all the problems of
justifying avant-garde painting would be solved at a stroke. How would anyone
be able to reproach them for painting pictures that no one could understand or
need, when examples of the new architecture were springing up everywhere,
proclaiming their ideas of colour?

In 1917 Mondrian ceased to incorporate trees, medieval church towers or sea
views into his new pictorial form. His pictures were now to be constructions
under a new, future heaven. *Composition* of 1916 had partly realised this notion.
But the appearance of the free-floating lines and patches of colour against the
pictorial ground still seemed to retain an echo of nature and landscape.

In 1918 Mondrian concentrated all his efforts on giving his pictures the static
stability that is the distinguishing feature of architecture. Theo van Doesburg
had designed a stained-glass window for a new building in 1917 (p. 53). Over
four sections filled with coloured rectangles, he had placed a black square in
diagonal position which determined the shape of the whole, while being slightly
reminiscent of a colourful kite floating in the sky. Mondrian was fascinated – he
adopted the motif for his new paintings.

The picture plane of *Lozenge with Grey Lines* (p. 52) painted in 1918 is filled
exclusively with simple black lines. Mondrian took the Cubist linear elements,

which he had often previously assembled as a grid over the white surface (cf. p. 43) and now for the first time enclosed them into a regular square network. One of the black grids runs parallel to the sides of the lozenge shape of the canvas; another, superimposed, follows the verticals and horizontals of the room in which the picture will hang.

The painting could have come straight off an architect's drawing-board, it is so simple. It has a regular, fixed framework that takes into consideration the forms employed in the construction as well as the environment in which the "architecture" of this picture is to be viewed.

At the same time, it represents a summation of Mondrian's work over the preceding few years. It is more symmetrical and, in the reduction of its components, more resolute than all his previous white paintings. Here the new pictorial form finds even better expression. The floating square of the canvas with its linear systems pointing in different directions is another reminder of the spinning coils in the paintings of van Gogh.

There could be no greater contrast to the notion, suggested in Mondrian's earlier *Compositions*, that all forms can be changed. No matter which angle the canvas is seen from, it always remains the same. There is no longer the merest trace of the poetic image of the white ground out of which shapes are conceived

Composition Chequerboard, Dark Colours, 1919
Compositie Dambord, donkere kleuren
Oil on canvas, 84 x 102 cm
The Hague, Haags Gemeentemuseum

In 1919 Mondrian introduced into his grid structure colours distributed at random. They are the colours of the city. He thereby sought to incorporate the uncontrollable nature of colour into the completely rational geometry of the grid.

Composition: Light Colour Planes with Grey Contours, 1919
Oil on canvas, 49 x 49 cm
Basle, Kunstmuseum, Öffentliche Kunstsammlung

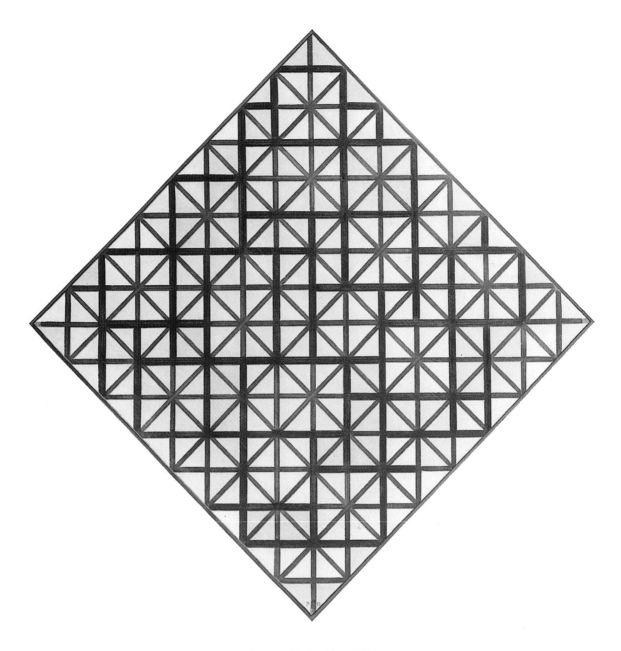

Lozenge with Grey Lines, 1918
Losangique met grijze lijnen
Oil on canvas, diagonal 121 cm
The Hague, Haags Gemeentemuseum

In 1918 Mondrian evolved grid paintings consisting of nothing but lines.
These are the most abstract of his paintings, and modern art did not
take up this development again until after 1950.

by the artist. While the large format of *Lozenge with Grey Lines* makes it appear as an entity floating free in the air, the painting itself has become static, classically formulaic and monumental. In the whole of modern painting, which had previously shown itself as spontaneous, colourful and enigmatic, there had never been a picture such as this.

The scale and severity of Mondrian's work at this time once again frightened away his newly-won admirers. H.P. Bremmer and his patroness, Mrs Kröller-Müller, now struck him off their list of artist protégés. The artists appointed to decorate palaces, hunting lodges and new museums with their paintings were supposed to make every effort to produce work that was both pretty and interesting. By 1918 Mondrian had gone far beyond that stage, and indeed his paintings would never again be as radically abstract as they were at that time.

It appears that he left the Cubist camp that year and surveyed what he had achieved. A largely naturalistic painting such as the *Self-Portrait* of 1918 (p. 44), incorporating an abstract picture in the background, would have been inconceivable any earlier for Mondrian. He would probably have regarded it as a betrayal of his attempt to paint in a consistently abstract manner. Now he had reached the stage where he could quite deliberately act as if abstract art and its latter-day Rembrandt – himself – were simply the better alternative to the classical painting of the Old Masters. They had painted themselves in the past in this very same pose, including examples of their own work in the picture.

Before executing this self-portrait, Mondrian followed Picasso's example once more. Picasso had begun to construct his own paintings like an object placed in front of a naturalistic backdrop (cf. p. 46). Mondrian saw that he could make his abstract lines and splashes of colour into the subject of a painting in

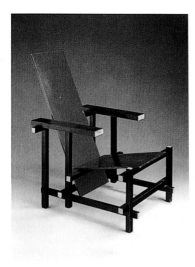

Gerrit Rietveld
Red/Blue Armchair, 1917/18
Düsseldorf, Torsten Bröhan Collection

Theo van Doesburg
Colour scheme for a room in the house of
Bart van der Ligts in Katwijk aan Zee, 1919
Watercolour on paper, mounted on card,
27 x 21 cm
The Hague, Rijksdienst Beeldende Kunst

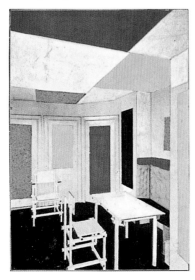

just the same way. The problem of what the paintings meant seemed to solve itself if the subject dealt with the artist and his work.

In autumn 1919 Mondrian returned to the regular framework of the linear grid, now filling it with colour. *Composition Chequerboard, Dark Colours* (p. 50) is an example. He distributes the colours at random and the colours chosen are from his paintings of the sea of Parisian houses. Although this makes the impact so technical as to strike the viewer more like a games' board than a painting, it nevertheless observes the traditional rules of painting. Drawing had always consisted of the intellectually controlled line – whereas colour represented the uncontrollable, nature itself.

The Parisian Cubists had always insisted they had arrived at their modern style as a result of analysing the painting of the past. Mondrian's colourful grid painting is completely abstract and in this respect far more radical than any Cubist picture had ever been. And yet it still fulfils the condition of being a painting in the old sense.

In the summer of 1919 Mondrian returned to Paris, where at first everything seemed virtually unchanged. His studio had been shut up for five years, and he found his blankets full of moth-holes, but all his paintings were well preserved. As he went round the latest exhibitions, however, he realised that something had changed after all. He found nothing in the whole of Paris to compare with his own new pictorial form. Picasso's return to more representational painting was a disappointment to Mondrian, as is evident from the first letters he wrote from Paris.

At that time much was being written by the Paris art world about colour and its sensual power – Mondrian read what they had to say and was no doubt influenced to produce the coloured grid paintings. He gradually came to realise that with the work he had done over the past few years, he had achieved what he had been trying to do since 1912: he had overtaken Picasso and Braque and become the most abstract and most modern painter in his field.

However, this triumph was soon followed by deep depression. He had felt at home in Paris, because he believed himself to be close to his artist colleagues, Picasso and Braque. Now this city had all at once become frighteningly strange to him. In addition to this, the income from Bremmer was about to come to an end. The bitterness that he had stored up over the years at the negative response to his work in the Netherlands now welled up with full force. He felt he had no one to paint for, and was overwhelmed by the loneliness of his success.

He decided to leave Paris. Like van Gogh before him, he wanted to settle in the beautiful regions of southern France. Yet Mondrian no longer believed that the experience of life in the South could rescue an artist who had lost his way. In the spring of 1920 he announced to Theo van Doesburg that he wished to mark the end of his artistic career with a farewell exhibition, after which he intended to begin working in the vineyards in the South of France.

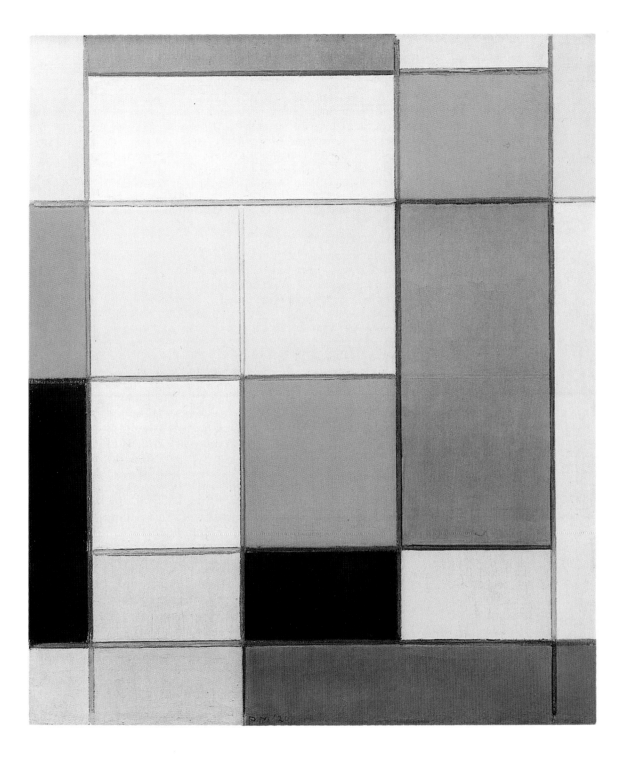

Composition with Red, Blue and Yellowish-Green, 1920
Compositie met rood, blauw en geel-groen
Oil on canvas, 67 x 57 cm
Ludwigshafen am Rhein, Wilhelm-Hack-Museum

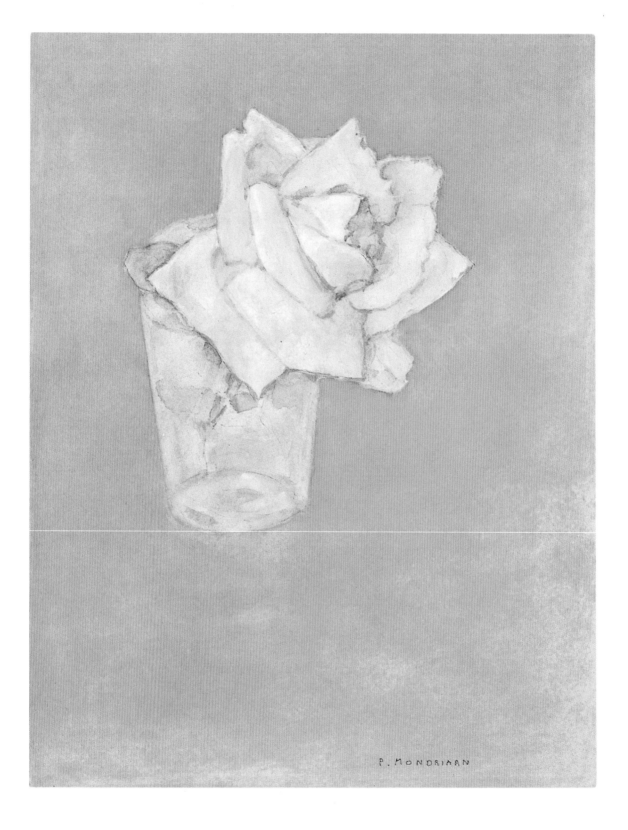

The Painter and his Stage –
from Abstraction to Style

In the event, things turned out rather differently. Mondrian remained in Paris. His Dutch artist friends secured him a modest, but regular income. Salomon Slijper, the collector, found clients for the flower paintings that Mondrian now began to paint in large numbers (pp. 20, 56, 61).

At the entrance to his studio Mondrian placed a small object – an artificial flower, whose green leaves he had painted white (cf. p. 57). Asked by a journalist what this was supposed to signify, he replied that this flower represented the missing woman in his own life, which was wholly dedicated to art. Dutch Protestants also liked to hang small flower pictures, like those painted by Mondrian, at the entrance to their houses. These would often include a few words from the Bible, such as "As for me and my house, we shall serve the Lord" (p. 20).

This reference to the established Protestant view of the world is an indication of Mondrian's desire for a social framework for his art. Since there was none, Mondrian constructed it himself. He exhibited his own studio as the workplace of a creative artist of enduring merit. The quasi-religious symbolism of the flower did not fit in with the modernity of Mondrian's art, but this clearly did not matter to him.

In the early twenties Mondrian gradually turned his studio into a model of interior design in the style of the De Stijl circle (p. 65). He decorated and painted the walls with large areas of colour, hanging his own pictures between them (cf. p. 66), so that they now appeared to be part of the bright overall pattern, merging into a continuum of colour.

Mondrian kept a few pieces of simple furniture and the old stove, but painted other items or built them himself. The white-painted easel was only used to display pictures. Had it been used for painting, it would probably have toppled over. This illustrates the extent to which the studio was arranged primarily for decorative effect.

On his return to Paris Mondrian had observed that there was no longer a clear distinction between art and decoration. Picasso was painting theatre curtains for the latest productions. In 1919 Mondrian made friends with Tour Donas and her husband, the sculptor Alexander Archipenko. Mondrian's imagination was kindled by this couple, who extended their art into everyday life and whose romantic lifestyle was oriented to their art.

With the emergence of Art Deco in Paris, where Mondrian had finally decided to stay, it had become virtually impossible to maintain that art was still dedicated to progress and spiritual values. He joined the trend towards decoration and, in addition to the artistic theory he had already evolved, he also created an environment and lifestyle that appeared to represent the values that abstract art was meant to express.

During 1919 and 1920 Mondrian concentrated on social engagements, on friendships and on writing about art theory. He returned to work in the studio in

André Kertész
At Mondrian's, 1926
Chez Mondrian
Silver gelatine print
France, Ministère de la Culture (A.F.D.P.P.)

ILLUSTRATION PAGE 56:
White Rose in a Glass, after 1921
Witte roos in glas
Watercolour, 27.5 x 21.5 cm
The Hague, Haags Gemeentemuseum

Mondrian was commissioned by clients to paint small flower pieces in the colours of his abstract canvases. But he also decorated his studio with a flower to transform it into a place of private myth, and thus created a setting where he would stage the new art. The studio became a changing colourful backdrop for photographs of himself and his paintings.

Title page of *De Stijl*, 1921

Mondrian was one of the most important contributors to the *De Stijl* magazine founded by Theo van Doesburg in 1917. In addition to essays on the theory of modern art, he also published in it two stage plays about painting.

ILLUSTRATION PAGE 59:
Composition, 1921
Compositie
Oil on canvas, 49.5 x 41.5 cm
Basle, Kunstmuseum, Emanuel Hoffmann Bequest

Mondrian's abstract style sought to present the elements of painting – lines and pure colour – in a performing role. He therefore turned away from pure grid and linear paintings and discovered instead the expressiveness of colour and form.

1921, the year which has long been regarded as the most decisive in his development. It was then that he succeeded in developing a new style which to this day is instantly recognisable as typical of Mondrian. It is characterised by brilliant primary colours – red, yellow and blue.

From 1909 to 1911 pictures such as *Windmill in Sunlight* (p. 14) and *Evolution* (p. 29) had already shown the characteristic trio of primary colours, but in 1911 this had disappeared abruptly. Now it returned. At first broken tones, such as yellowish-green and orange (cf. pp. 55, 59) were still included and the varied grey and blue hues of the white ground recall the colours of a cloudy sky. By the end of 1921 the pictorial grounds have become uniformly white and the colours pure. The change in style and the return to primary colours once again coincided with a tragic event in the life of the artist – in 1921 his father died.

Mondrian had evolved the pictorial ideas which he now put into action even before 1921. In letters written to van Doesburg in 1919 he expressed frequent dissatisfaction with his work. The radical modernity of his grid paintings no longer interested him; he bemoaned their lack of variety and scale, balance and proportion. In paintings such as *Composition: Light Colour Planes with Grey Lines* (p. 53) and *Composition: Light Colour Planes with Grey Contours* (p. 51) he experimented with pictorial fields of varying sizes in an attempt to recapture the lost rhythm of his works of 1916 and 1917. The reduction of painting to its elementary components was now to become the basis of a richer art of colourful ornamentation – style would replace the abstract.

In 1920 he began to enlarge the individual zones within the picture and fill them with strong colours (cf. p. 55). Because there were fewer fields in the painting, the overall effect was less regular. Mondrian discovered that enclosing the colours in a grid at once heightened their special quality, their atmospheric and visual impact. For although the rational organisation of the pictorial field confined the colours, they appeared to be discharging their own power. It often looked as if the colours might set the external structure in motion from within.

In the centre of *Composition with Red, Blue and Yellowish-Green*, (1920; p. 55) are four small squares. The square in the lower right corner is red and gives the impression of falling downwards and forwards. The one on the lower left is greyish-white and appears to be straining backwards and upwards, because its effect is lighter and at the same time more restrained in colour than the yellow squares above it. There thus seems to be a circular clockwise motion emanating from this block of four. Once again van Gogh's legacy of spinning coils is revived in Mondrian's painting. Even the surrounding border of larger elements, seemingly heavier in colour, is drawn into this movement. It might be compared with a wheel turning in time with the ponderous rhythm of the composition.

Throughout 1921 Mondrian kept to the principle of visually loosening the grid to set it into apparent motion. But the tone and mood of this endeavour now changed dramatically – in *Composition with Red, Yellow, Blue and Black* (p. 62) a large red square glows out of the upper left centre of the painting, while to each side yellow is applied onto fields of the grid which are left open where they meet the edge of the painting. The colour thus extends right up to the edge of the pictorial field and seems to continue beyond it. Not all the black lines of the grid extend to the edge of the painting, which is a decisive innovation. It creates the impression that the black linear network is a free-floating construction, invented by the rational thought of the painter, which exists in the middle of an endless, luminous field of colour.

In a burst of unlimited creativity throughout this year Mondrian worked at producing dramatic illusions. In *Composition* (p. 59), now in the Basle Kunstmuseum, brilliant orange and yellow fields soar upwards, while dark

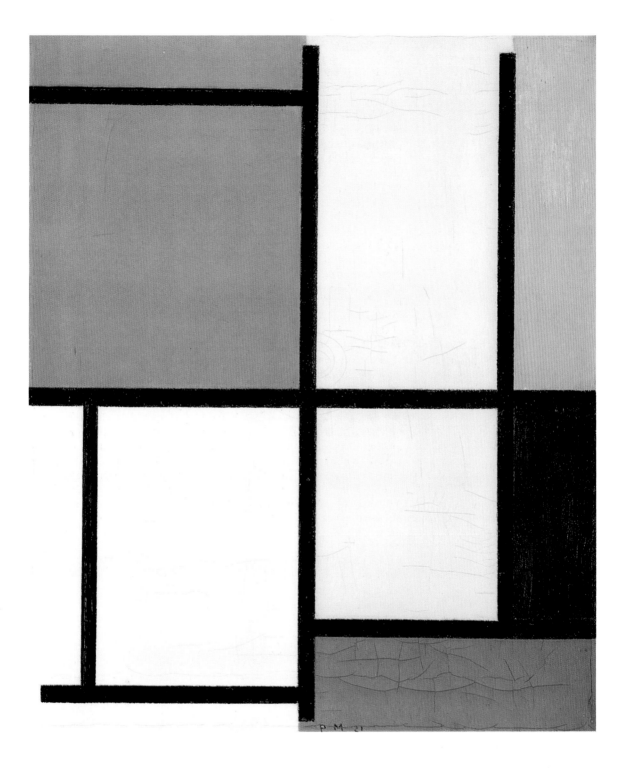

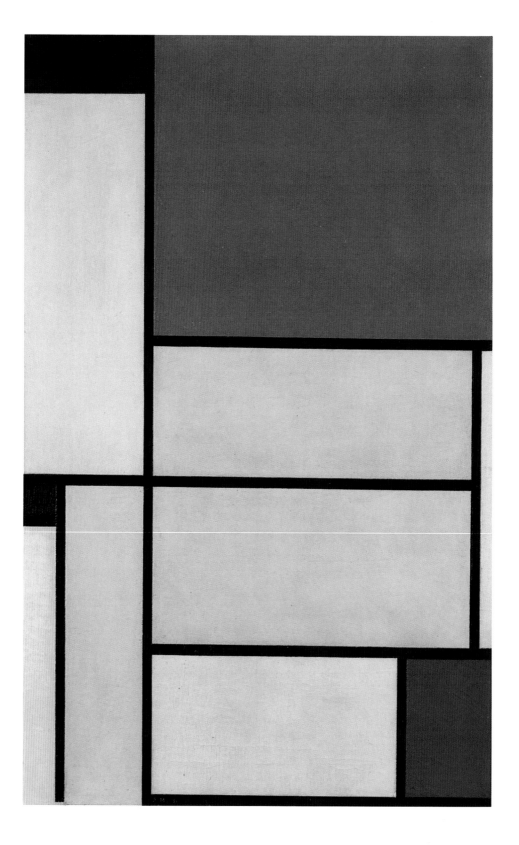

P. MONDRIAAN

Lily, after 1921
Lelie
Watercolour and coloured pencil on paper,
25 x 19.5 cm
The Hague, Haags Gemeentemuseum

ILLUSTRATION PAGE 60:
Tableau I, 1921
Oil on canvas, 96.5 x 60.5 cm
Cologne, Museum Ludwig

black and blue ones exert a downward pull. The insertion of a large black linear
cross is a new feature, carrying the entire picture on powerful axes. The upward
and downward pull of the colours does not, however, result in a visual fragmen-
tation of the whole, but instead gives it the appearance of a vertically-oriented
unity.

Tableau I of 1921 (p. 60) also reveals an architectural solidity of structure.
The block-by-block composition of the coloured elements is reminiscent of
Mondrian's early church tower paintings. Here, too, the red rectangle seems to
be rising slightly, yet because it is shaped rather like a brick with the width
slightly exceeding the height, it remains visually within the picture.

The narrative expression that Mondrian was aiming at in such paintings
affected his working methods. He could now no longer simply fill a grid with
colours and play the creator, distributing them randomly as in nature. Painting
a picture now became an increasingly difficult task, requiring constant over-
painting in the exploratory search for a solution.

This often lengthy developmental process is evidenced in the texture of the
paintings as seen today: deep cracks have spread across the layers of paint that

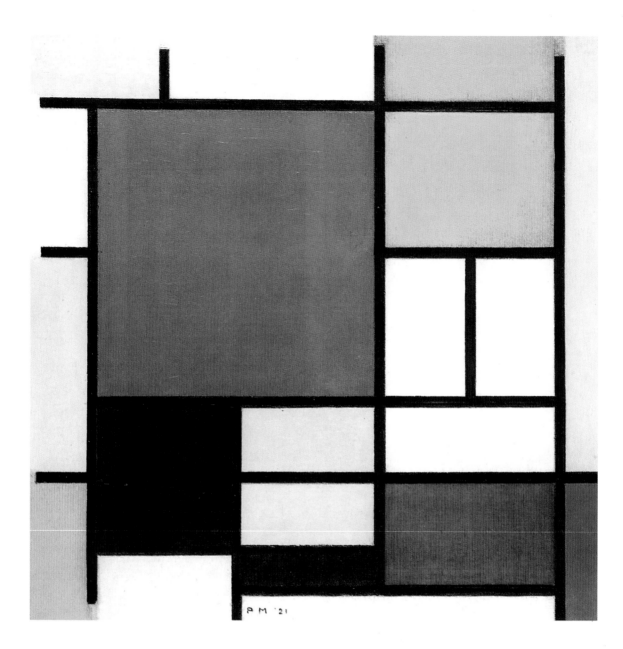

Composition with Red, Yellow, Blue and Black, 1921
Compositie met rood, geel, blauw en zwart
Oil on canvas, 59.5 x 59.5 cm
The Hague, Haags Gemeentemuseum

In 1921 Mondrian produced a series of masterly paintings that come alive
through the power of large areas of red and blue and the apparent
"ascending" or "expanding" motion of the colours.

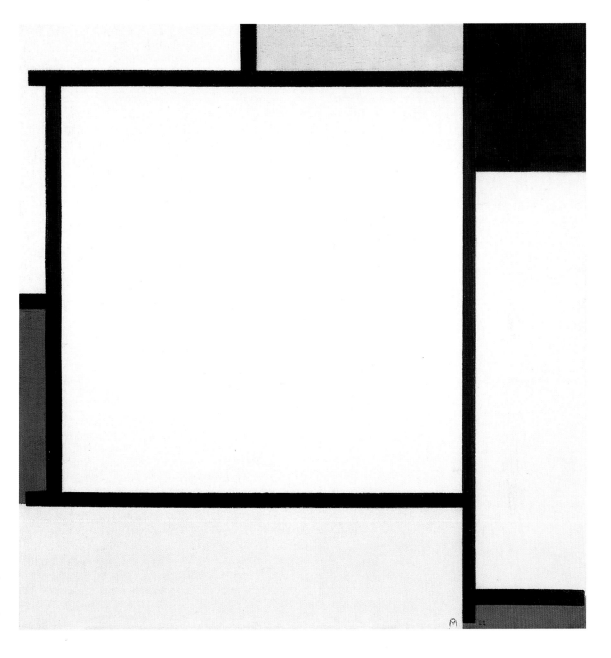

Composition 2, 1922
Compositie 2
Oil on canvas, 55.5 x 53.5 cm
New York, The Solomon R. Guggenheim Museum

At the same time as he was experimenting with moving areas of colour,
Mondrian discovered the empty centre of the composition. The white
plane with its suggestion of radiating force became a recurring
theme from 1921 onwards.

Theo van Doesburg
Contra-Construction, Artist's House, 1923
Contre-construction, Maison d'artiste
Pencil and pastel on tracing paper, 37 x 38 cm
The Hague, Rijksdienst Beeldende Kunst

have turned brittle with the years. Mondrian was impatient at the time it took for the oils to dry and frequently used petroleum as a solvent, which was highly unsuitable in conservation terms. The surfaces of his paintings are extremely difficult to clean; many look dirty and tend to crumble away in places.

Mondrian now withdrew from the social scene and worked hard and without interruption on these seemingly very simple paintings. In so doing he established a myth. He has since been repeatedly described – in an almost unacceptable stereotype of what he really was – as a monk or a saint of painting, a "priest officiating at the white altar". And yet this may not have altogether displeased Mondrian. As a young man, he had drawn pictures of the Christian martyrs and knew that it was their lives of sacrifice that had contributed existential significance and historic impact to the church's teachings, which had previously consisted only of dogma. He would have liked his own work to be a necessary part of history.

He began by turning his own life into a legend. From now on he became highly selective in what he disclosed about himself and destroyed all his correspondence and many documents from his early years. The way he furnished his studio was intended as a statement of his own theories. He wanted to eliminate everything personal from the image of himself, and above all to banish the memory of the bad times of his youth. He wished to reinvent himself and re-write his own biography. Nothing should remain in the public memory other than a reminder of a life dedicated to pure form.

The pictures produced after 1921 proclaim an ever greater preference for empty white surfaces. Mondrian's concept of the classical within the new art merges with the ideal of objectivity. The strident colours in the small dramatic paintings of 1921 give way to more sublime creations.

In *Composition 2* of 1922 (p. 63) the colour planes have been driven to the very edges. They no longer move with speed, because the illusion of a clockwise motion is inhibited, particularly by the blue rectangle at the left edge. Yet the whole composition, rather than remaining visually static, appears to be quietly breathing. The vertical that runs the length of the right hand edge lends stability, and the broad interval between the fields of colour conveys an impression of expansiveness and calm. The centre of the painting shows nothing but a white surface. This picture clearly consists of little more than a few lines and planes on a white background which is also clearly visible at the lower edge. The abstract quality of the painting is more distinctly tangible than ever before in Mondrian's work.

At that time Mondrian would not allow himself to be photographed while painting, as he had done in 1905. A Dutch press photographer had to assemble a photomontage (p. 67) when he wanted to show him in his new studio. A photo of the studio that Mondrian did permit in 1926 (p. 65) shows the easel in the middle of the far wall, and on it one of the paintings with the centre left in white. The master is not present – an open book he has apparently just been reading shows him to be an intellectual. Mondrian often said that "new life" could be found in the free space opened up by reason and thought. The empty plane at the centre of the small painting on the easel reflects the absence of the artist.

During this period Mondrian frequently spoke of the end of the subject in the new age to come. He designed his studio as an imaginary setting for a theory without an author, where the "new" appears to evolve in the non-space of the empty centre of his abstract paintings.

The same photograph shows a small model of a stage set to the left of the painting. Mondrian had the idea of staging a play by his friend Michel Seuphor entitled *The Ephemeral is Eternal (L'Ephémère est éternel)* against this backdrop. The rear wall of the model reveals a combination of large light and

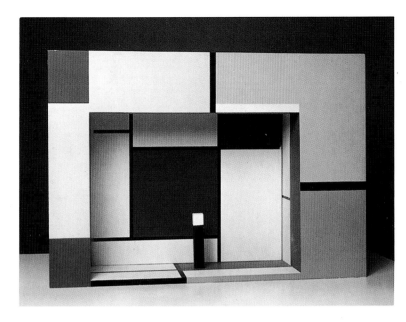

ABOVE:
Model of a set for Michel Seuphor's
play *L'Ephémère est éternel*, 1926
(reconstruction 1964)
Card on wood, 53.3 x 76.5 x 26.5 cm
Eindhoven, Stedelijk Van Abbemuseum

CENTRE:
P. Delbo
Mondrian's studio, 1926
Photograph
The Hague, Haags Gemeentemuseum

BELOW:
Mrs B.'s Drawing Room, 1925
Designs for Ida Bienert's library, Plauen
Opaque watercolour,
37.5 x 56.5 cm, 37.6 x 56 cm
Dresden, Staatliche Kunstsammlungen

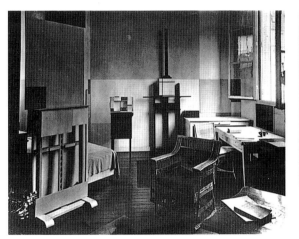

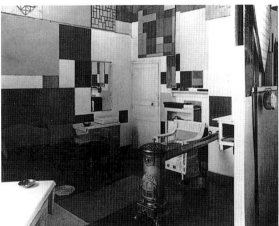

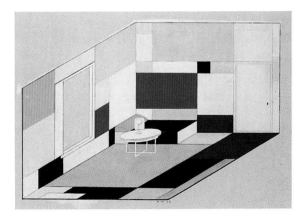

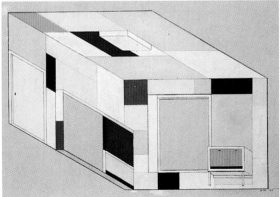

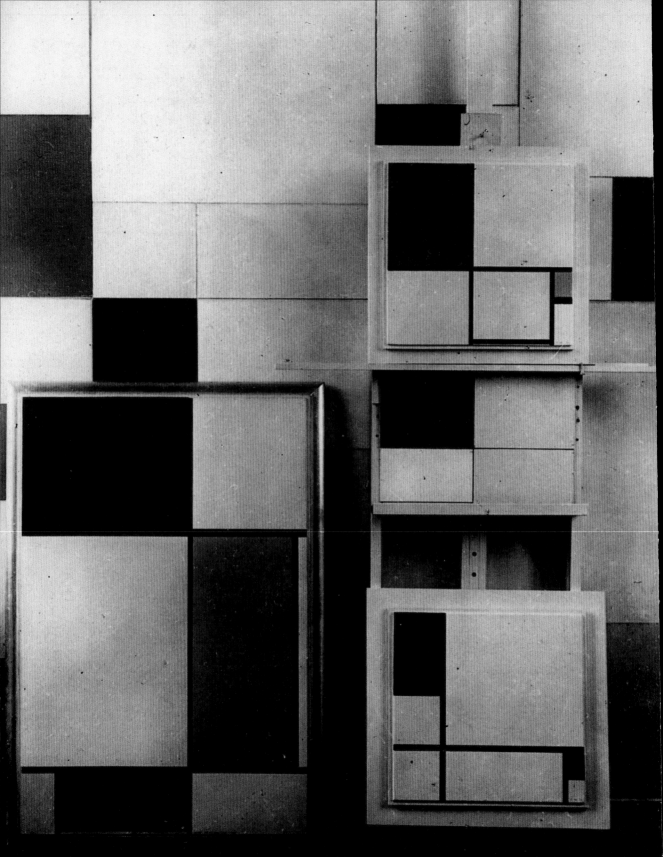

dark rectangles similar to that on the far wall of his studio. In setting up the small model next to his painting in the 1926 studio photo, Mondrian was making a statement: here is a stage, furnished with abstract forms. He had written a play himself in 1919, with the final scene set in his own studio. The theatrical element played a major role in his concept of painting at that time. The drama of the colours gave a content to the picture with its solely abstract ornamental forms, and transformed it into what Michel Seuphor wrote about – the ephemeral rendered eternal.

It has to be said that this introduction of the theatre element had nothing to do with the avant-garde, all-embracing approach to art in the manner of De Stijl. The experimental theatre of the time was always concerned to eliminate the separation between stage and auditorium. Theatre people must have been taken aback by the highly traditional nature of Mondrian's stage design.

The same is true of the architectural drawings produced by Mondrian. The curiously dilettantish character of his design for the library of Ida Bienert in Plauen (p. 65) is immediately apparent from the way he chose to present it – like looking into a doll's house.

What led Mondrian suddenly to design architecture for clients? He probably wanted to compete with van Doesburg, for he had realised that their ideas were no longer compatible. By the beginning of the twenties, van Doesburg, working with Cor van Eesteren, was already on a completely different, more forward-looking track.

He had dissolved the conventional relationship between living areas and conceived modern architecture as an ensemble of colour planes in an abstract, infinite space (cf. p. 64). In so doing he was following the dominant principle of modern architecture, construction: the mathematically-calculated and constructed form was no longer bound to a specific material space.

Mondrian could not, however, accommodate such avant-garde architecture in his philosophy, although it was just as modern as his own painting. He intended his abstract painting to be as relevant in the context of natural space as the art of former times had been.

The split with van Doesburg was now inevitable. Contrary to the legend of the two great artists falling out like two squabbling children over diagonals in a painting (for which there is no conclusive evidence, either documentary or based on their work), it must be assumed that the break was actually caused by a fundamental difference in their perception of space and form. In keeping with his long-established concept of space, Mondrian's peep-show stage contained few diagonals and none of the free-floating, overlapping forms seen in van Doesburg's architectural designs (cf. p. 64). The painter stood firm and unmoved in the classical arena of his own stage. From now on Mondrian took no more part in any of the De Stijl projects.

Instead we find his paintings in Hanover's Provinzialmuseum, where the Russian artist El Lissitzky had been commissioned in 1928 to install the so-called "Abstract Gallery" (p. 68). The room contained mainly works of the Constructivist trend in modern art and was destroyed in 1936. The interior was constructed with strictly geometric elements and included sliding walls, which could show particular paintings or make them disappear, depending on their position.

Unfortunately there is no record of Mondrian's reaction to such unusual display techniques. Although these techniques were not unlike the arrangement of his own studio, they also showed in a museum setting how art could be applied to the décor of the everyday living room. What we do know is that, in the second half of the twenties, Mondrian returned to a much larger format and to the white surface, favouring a strikingly simple design.

Mondrian in his studio, 1926
Photomontage in the *De Telegraaf* newspaper, 12 September 1926

ILLUSTRATION PAGE 66:
In Piet Mondrian's studio, c. 1930
Photograph
The Hague, Haags Gemeentemuseum

Resting on the easel is *Composition II with Yellow and Blue* of 1930, below left is *Large Composition with Red, Blue and Yellow* of 1928, and below right *Composition* of 1929. Mondrian also painted the easel and the walls, enabling the paintings to be seen as part of a total work of art set in the studio space.

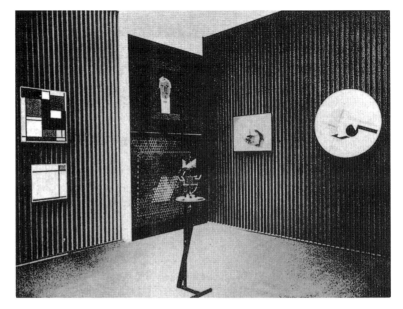

El Lissitzky
The Abstract Gallery, c. 1928

The *Abstract Gallery* in the Provinzialmuseum in Hanover was installed in 1928 under the direction of Alexander Dorner. This influential art historian used the ideas of the avant-garde artists as the basis for his own studies.

On the left-hand side of a photograph of his studio dating from 1930 (p. 66) the painting *Large Composition with Red, Yellow and Blue* of 1928 can be seen. It has three basic colour planes which indicate a virtual return to one of the simple grid pictures. The painting has a distinctly traditional gold frame, showing that there was also room in Mondrian's studio for the easel paintings of the past.

The two other pictures are mounted on the white board frame developed by Mondrian, which is set back from the canvas so that the picture itself is free-standing. This type of frame establishes an immediate relationship with the studio space. The principal motif of the *Composition* (1929) in the bottom right hand corner is a large white field open at the upper edge. Contradictory as it may sound, there seems to be pathos in the very plainness of this small picture.

Composition with Two Lines of 1931 (p. 70) originally hung in the newly-built Hilversum Town Hall, designed by the architect Willem Marinus Dudok. All Mondrian did was to take two simple black lines to indicate the horizontal and the vertical that determine his pictorial grid. Since these also constitute the fundamental directions of architectural construction, the relationship between architecture and painting is presented in the simplest possible way – in a continuum, extending in the mind beyond the edges of the painting, of a white plane and that mathematically conceived, unconfined space with which all modern architects and avant-garde designers were working.

However, the white square in lozenge format was hardly likely to fulfil its intended purpose of adorning the concrete expanse of the town hall. At any rate the people of Hilversum were none too happy with their painting and sold it to Amsterdam. In this period, as if undermining the self-decreed references in his painting to landscape, art and architecture as a decoratively-conceived whole, Mondrian placed a particular emphasis on the abstract quality of his painting, which no longer related to anything representational. He thereby arrived at a point in his artistic development that could take him no further – after this painting, what was there left to paint?

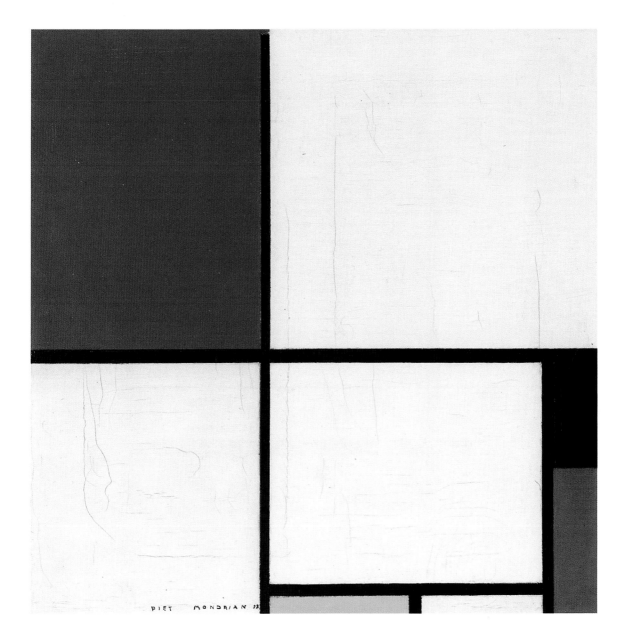

PIET MONDRIAN 28

Composition with Red, Yellow and Blue, 1928
Compositie met rood, geel en blauw
Oil on canvas, 42.2 x 45 cm
Ludwigshafen am Rhein, Wilhelm-Hack-Museum

Towards the end of the twenties, the expressive power of the colour and
white planes intensified. A series of paintings is dominated by a single
large white or colour plane, adjoining the edge of the painting on two
sides.

Composition with Two Lines, 1931
Compositie met twee lijnen
Oil on canvas, diagonal 114 cm
Amsterdam, Stedelijk Museum

Mondrian took radical abstraction to even greater extremes in 1930/31 in
the paintings of black lines on a background of white, bringing him to a
point beyond which no further development seemed possible.

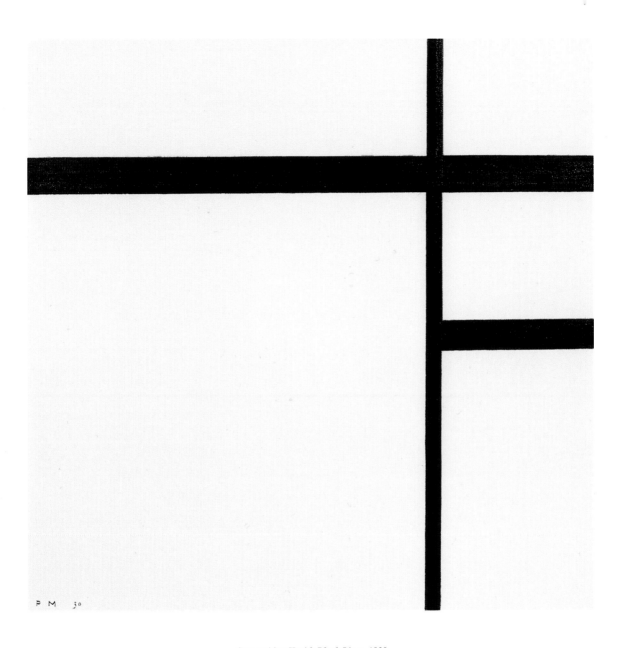

Composition II with Black Lines, 1930
Compositie nr. 2 met zwarte lijnen
Oil on canvas, 50 x 51 cm
Eindhoven, Stedelijk Van Abbemuseum

Around 1930 Mondrian was painting pictures for architectural interiors,
consisting of only two black lines meeting on a white background – the
imaginary stage for his art.

Mondrian in his studio in front of
Composition with Yellow Lines and *Composition with
Colour Square*, c. 1933
Photograph
The Hague, Haags Gemeentemuseum

Composition with Yellow Lines, 1933
Compositie met gele lijnen
Oil on canvas, diagonal 133 cm
The Hague, Haags Gemeentemuseum

In 1933, Mondrian succeeded in pushing to the very limit the distinction
between line and colour, as understood by both Cubism and the entire
tradition of painting, by means of the imagined "mechanisation" of
pictorial design. The traditional distinction between the elements of
painting are suspended, with the merging of line and colour.

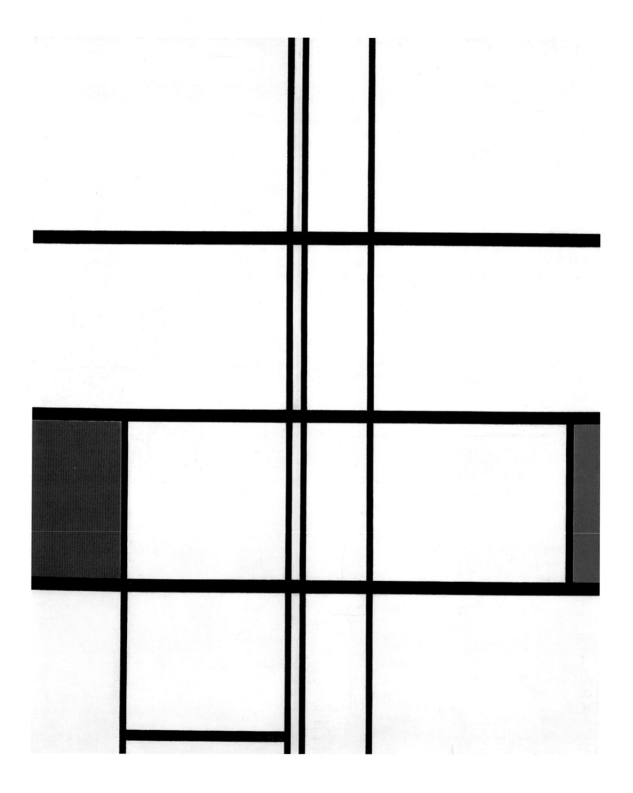

The Echo of Lines – Mondrian's Late Paintings

In 1932 Mondrian turned sixty. In recognition of his achievement as an outstanding artist tributes appeared in the press and a major exhibition of his work was mounted at Amsterdam's Stedelijk Museum. Many considered he had reached his definitive art form. The public had meanwhile grown accustomed to his virtually unvarying style of composition using red, yellow and blue (cf. p. 69). Mondrian's new white pictures appeared to have reached the limits of painting.

In a book completed in manuscript form in 1931 under the title of *The New Art – The New Life (Le Nouvel Art – la Nouvelle Vie: la culture des rapports purs)*, Mondrian proclaimed that the end of art was imminent. This end would include the end of the Old World, and thereafter the "new life" and the dawning utopian era could profit from the energies formerly used to produce works of art during the dark ages of the human race.

The text also revived old theological allusions – Mondrian repeated the prophecy of the "great conflagration" yearned for by the members of his church. Stripping away the apocalyptic rhetoric, one astonishingly illuminating idea remains: art was to remain aware of its possible end and of its lack of historical direction. This was in fact the historic situation of abstract art. Its forms no longer related to everyday experience, and knowing this, the artist had to accept the likelihood that it might soon be impossible to go on painting.

In 1932 a number of friends commissioned Mondrian to paint a picture representative of his artistic standpoint, as a gift to the museum in The Hague. He completed *Composition with Yellow Lines* (p. 73) in 1933. As in previous white paintings, there are only a few lines. They no longer overlap and accordingly do not form a cohesive figure in the pictorial field. Mondrian chose to paint them an astonishing brilliant yellow. The lines are abruptly sliced by the edges of the painting, giving the impression, as in the earlier white paintings, that they could have continued beyond the panel; more than this, however, these sunny rays of a new, vividly colourful art appear to meet only outside the painting. The arrangement of particular forms of light and shade, of colour and drawing has not yet occurred.

Even at first glance this composition – "design" is a term that springs to mind – was in flagrant violation of every rule of art. Mondrian himself had laid down that any lines drawn in paintings done in his style had to be black, and that only the coloured areas or rectangles could be red, yellow or blue. These rules had led to his being accused of cheap dogmatism, an indication of how his art had been totally misunderstood. In fact, it was only by observing the strictest demarcation between colour and drawing that abstract art could uphold its claim to be painting in the old sense of the word. In the Italian Renaissance the resources of draughtsman and artist, *disegno* and *colore*, had been defined as ground rules for art and even the Cubists had not had the courage to challenge this cornerstone of western painting.

A.E. Gallatin
Piet Mondrian in his studio, 1934
Silver gelatine print
Philadelphia (PA), Philadelphia Museum of Art, A. E. Gallatin Archives

ILLUSTRATION PAGE 74:
Composition with Red and Blue, 1936
Compositie met rood en blauw
Oil on canvas, 98.5 x 80.3 cm
Stuttgart, Staatsgalerie Stuttgart

After 1932 Mondrian returned to the principles of repetition, serial work and copying, which had often helped him forwards in the past. He had started in 1896/97 with a series of copies based on the Old Masters. He now copied the black line itself, developing the characteristic "double line" which he continued to develop throughout the thirties in complex linear networks.

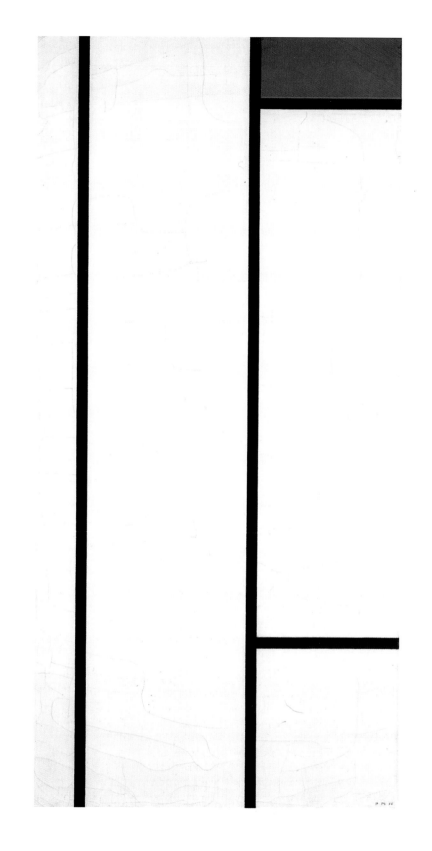

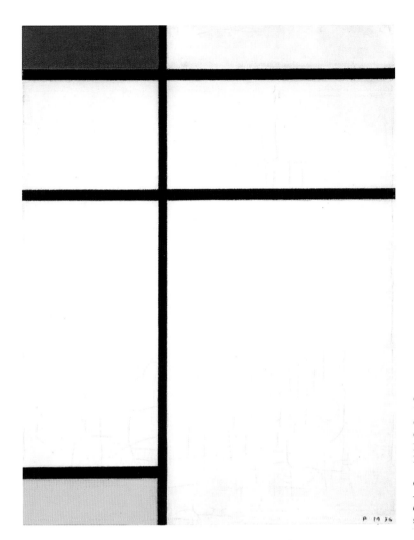

In the 19th century the Impressionists had already attempted to construct paintings using colour alone, but their pictures still contained recognisable human figures or views of nature. Surely pictorial art that was non-representational and did not use the conventional media of painting had nowhere left to go? This was clearly the end of traditional painting and Mondrian would seem to be celebrating the fact in his picture of 1933. That was his contribution to the pantheon of Dutch art in The Hague Gemeentemuseum's collection.

The fact that he was not necessarily entering the sphere of the unknown and the new, suggested by the ecstatic qualities of the brilliant yellow and white colouring in his new painting, is evidenced in certain similarities with his own earlier pictures. But as he still had the past to refer to in his own early work, at this stage he could bid a fond farewell to classical painting. Advancing years had brought him to the state of self-sufficiency that he had often dreamed of, making him blissfully indifferent to all external threats. Mondrian had often tried to create pictures consisting solely of colour, and his *Composition with Colour Planes No. 3* of 1917 (p. 49) is ample evidence of the decorative potential of this venture.

Self-Portrait, 1942
Zelfportret
Pencil and ink on paper, 29.8 x 22.8 cm
New York, Sidney Janis Collection

ILLUSTRATION PAGE 79:
Composition with White, Red and Yellow,
1938–42
Compositie met wit, rood en geel
Oil on canvas, 79.5 x 62 cm
Los Angeles (CA), County Museum of Art,
Mr and Mrs William Preston Harrison
Collection

An unfinished painting by Mondrian has survived from 1914. It is one of his compositions on the theme of the church façade, in his newly adopted style of filling the entire surface, but here using patches of colour only. He abandoned it probably because at the time he found it impossible to create a picture consisting only of colour without an organising linear structure. In 1933 he finally returned to his long-cherished aim of painting a picture with a uniformly patterned surface, without a centre or an ordering structure, and consisting only of primary colours. In his fusion of line and colour, he thus abandoned the link with tradition and opened up a new dimension in painting.

The photograph taken in 1933 of Mondrian in his studio (p. 72), standing in front of *Composition with Yellow Lines*, also includes another work from around the same period – *Composition with Coloured Square*. This painting introduces the second new element in his work during the period from 1932 – the double black line, representing a compromise between a grid and a simple black line. The lines have a form but the doubling prevents them from standing out as a clearly defined figure. The larger forms in the painting are simple, but the overall effect is nevertheless complex because the structure is not immediately apparent.

What made Mondrian introduce the double line? Rumour has it that he met the painter Marlow Moss at this time and took over the double line from her work. Whether this is true or not, it is hard to recognise the artist's familiar signature in this motif. The effect of the picture is so new and technical that the artist in his suit posing beside it looks like a left-over from a bygone age.

Composition with Red and Blue (p. 74) dates from 1936. This, too, has a larger format than most of the pictures painted in the twenties and the white area divided by a few black lines makes a very clear impact. On the extreme edges are two simple coloured sections, looking as if the black lines have pushed them to the sides. It is difficult to analyse the composition of the black structure. There are three vertical and three horizontal axes, but why the vertical lines have been placed at irregular intervals is impossible to fathom.

To question the structure of a picture and to try and understand it is just as much part of the tradition of western painting as the distinction between *disegno* and *colore*. A painting constructed according to the rules of perspective and the laws of proportion, and with a decipherable meaning apparent in everything portrayed in it, was considered a good picture. To this day the usual approach in the context of art, whether in art classes, museum tours, or in books such as this one, is to try to establish a link between the analysis of a painting and its interpretation.

At one time Mondrian had kept to recognised structures that had names and were generally considered expressions of reasonable formal rules. The regular grid had been one of these. Over the centuries connoisseurs of painting had grown accustomed to looking at simple lines. There has always been reference to the axes and the major lines of a composition, even though these were not so immediately clear and obvious in the works of the Old Masters.

The issue of the double line did not arise then, however, for a single drawn line is enough to convey the outline of an object. Two parallel lines immediately suggest a kind of aesthetic frivolity and Mondrian was well aware of this. In his earlier years he had felt very drawn to the spirit of Art Nouveau and to Gustav Klimt in particular. As early as 1898, he had used the playful, ornamental force of the double line for the parallel furrows in his watercolour *At Work / On the Land* (p. 10).

Composition III with Blue, Yellow and White (p. 77), also painted in 1936, still has much in common with the small pictures of the twenties. It does of course have a double horizontal axis and the two colour planes lie directly

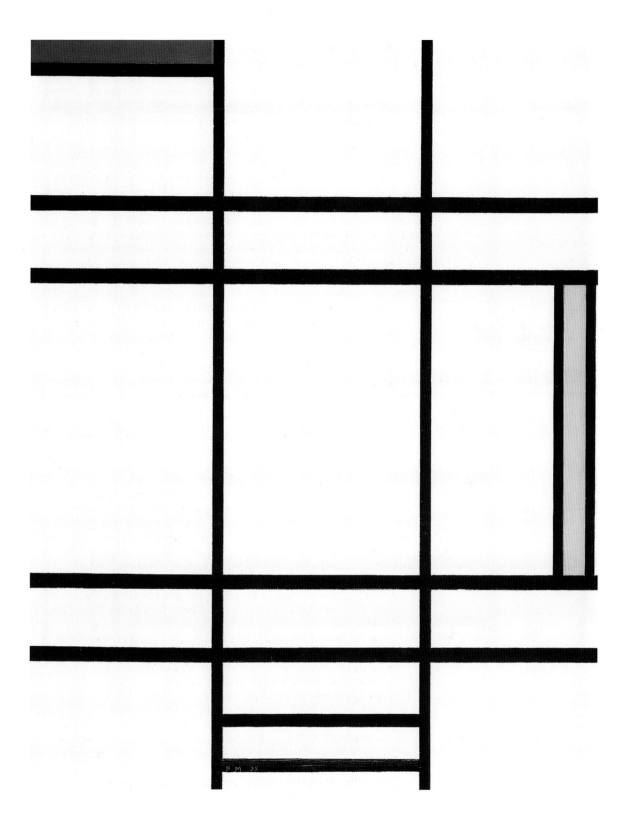

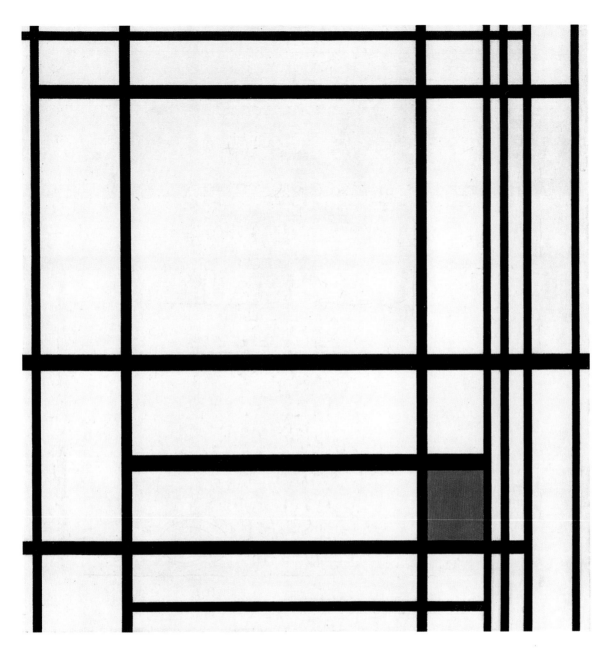

Composition with Blue, 1937
Compositie met blauw
Oil on canvas, 80 x 77 cm
The Hague, Haags Gemeentemuseum

Even in the new paintings with their complex double-line motifs,
Mondrian achieves quite distinctive expressions. Some of the paintings
look modern and quite technical, while others convey an impression of
harmony and almost classicism.

Composition with Red, 1936
Compositie met rood
Oil on canvas, 50.7 x 50.4 cm
Philadelphia (PA), Philadelphia Museum of Art,
A. E. Gallatin Collection

Composition with Red and Black, 1936
Compositie met rood en zwart
Oil on canvas, 102 x 104 cm
New York (NY), The Museum of Modern Art

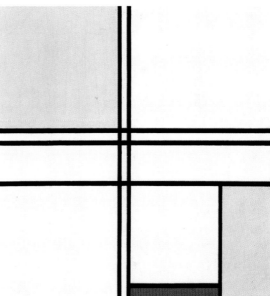

Composition, 1939
Compositie
Oil on canvas, 105.2 x 102.3 cm
Venice, Peggy Guggenheim Collection

Composition with Red and Grey, 1935
Compositie met rood en grijs
Oil on canvas, 57.5 x 55.6 cm
Chicago (IL), The Art Institute of Chicago

Composition with Red, Yellow and Blue, 1939–42
Compositie met rood, geel en blauw
Oil on canvas, 72 x 69 cm
London, Tate Gallery

The grid extending right across the picture plane returns in the works of
the late thirties, as does the controlled play with chance. The combination
of black and coloured lines in this painting achieves a cheerful note.

Composition with Black, White, Yellow and Red, 1939–42
Compositie met zwart, wit, geel en rood
Oil on canvas, 79.3 x 73.5 cm
Washington (DC), The Phillips Collection

Red lines cross the black network like flashing lights. The multiple colours of the linear network produce different optical effects.

opposite each other along the vertical axis in symmetrical proximity to the picture's edge. The initial impression is of a composition constructed mathematically along a mirror axis. Closer examination does not bear this out and yet the picture seems like a variation of the earlier paintings, although changed by the doublings and the mirror effects. The doubling of a line not only robs it of its function in the classical sense, namely to serve as a defining contour in a drawing. It also ends up as a copy of itself.

Mondrian had been copying old pictures of the martyrs (cf. p. 8) as early as 1896/97, thereby supporting the aims of his church to lend substance to the new by copying the old. At a later stage, he copied Picasso's style of painting. And now he began to copy himself.

Works like *Composition with White, Red and Yellow* of 1938–42 (p. 79) acquire a new, filigree monumentality, yet with a technical quality of mechanical repetition which reinforces the abstract character of the pictures. Mondrian's output now increased and in composing his works, he consistently seemed to abandon himself to this principle of mechanical repetition, until artistic discretion intervened. The colour planes often take on this role, frequently appearing in isolation (cf. pp. 80, 81). In pictures such as *Composition with Blue* of 1937 (p. 80) he even succeeded in giving the linear grid almost classical proportions. This alone would have fulfilled his long-held ambition to be the "Rembrandt of Ornament".

Whereas in the twenties Mondrian had never allowed himself to be photographed at work, and as late as 1933 still posed in a dark suit in front of a

Jackson Pollock
Summertime: No. 9A, 1948 (Detail)
Oil and enamel on canvas, 84.5 x 549.5 cm
New York (NY), Lee Krasner Pollock

Even in his very last works, Mondrian was
still in tune with the objectives of the most
avant-garde artist of the time. He considered
Pollock to be one of the most interesting
painters of the new generation of artists.

finished picture, he was now quite happy to have portraits of himself taken in front of unfinished paintings, and even wearing his painter's coat (p. 75). He liked to be seen as "technician of the new".

His desire to bid farewell to the old Europe and its painting was also reflected in his plans to emigrate to America. In 1934 a handsome young art student from New York, Harry Holtzman, had sought him out. To Mondrian, he seemed to personify the possibility of a completely fresh start. In September 1938 Mondrian wrote to him, "You know, I've always wanted to come and live in New York, but I didn't have the courage to try." In 1938 he first went to London, where he felt safe from the danger of war. But in 1940, when a bomb fell on the Hampstead house where he was living, he left for New York.

It was only after he left Paris that Mondrian returned to the discovery he had made in 1933. He now combined black with coloured lines, and instantly the sonorous classical effects disappeared. In pictures such as *Composition with Red, Yellow and Blue* (p. 82) and *Composition with Black, White, Yellow and Red* (p. 83), both painted between 1939 and 1942, the impression of playfulness reappears, with intersecting lines in different colours producing visually brilliant, flickering effects. In *New York, New York* (p. 85) it seems as if a network of coloured lines outside the picture is moving inwards to join the grid of black lines. The systematic contrast between colour and non-colour disappears completely. Mondrian now often called his paintings "New York". Here in this city he no longer staked out an imaginary terrain for a new life, in strict demarcation from reality. He spent what were probably his happiest and most carefree years here. In a dramatic gesture he detached himself from his earlier life – he disinherited his brother, and appointed Harry Holtzman as his sole heir and executor.

In 1941 he wrote a quasi-autobiographical prose piece, entitled *Toward the True Vision of Reality*. This "true vision" was, of course, the one that Mondrian had thrown out of his studio window, and through which he had tried to prove from 1914 onward that the essence of the world could better be captured by abstract painting than by representational methods of portrayal. In a survey of his life, Mondrian now wrote as if he had lived in his studio from the time of his birth. He described a life such as he had never lived, a dream life, stylised as a work of art and as the imaginary source of his art. This goes some way towards

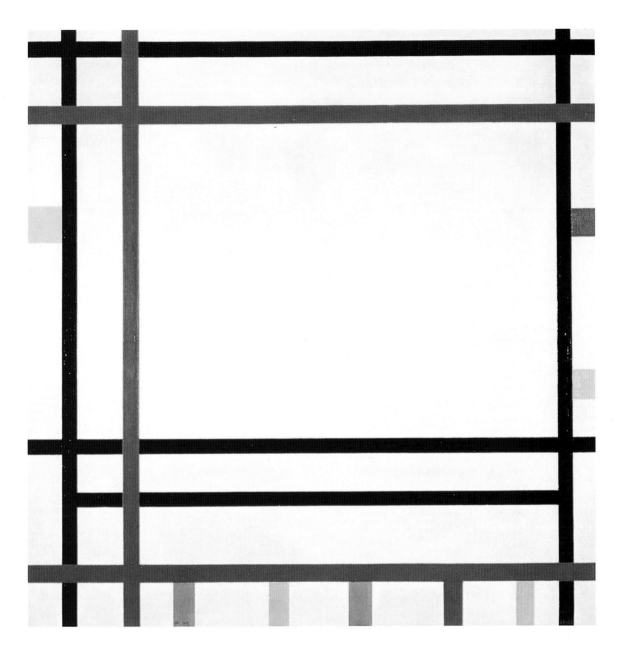

New York, New York, 1941/42
Oil on canvas, 94 x 92 cm
New York (NY), Hester Diamond Collection

"New York" is the most frequent title of Mondrian's late paintings. After
moving from London to New York in 1940, he developed a new pictorial
structure. Stripes of colour are incorporated into the black linear network,
gradually displacing it altogether, until it finally dissolves.

New York City I, 1942
Oil on canvas, 119.3 x 114.2 cm
Paris, Musée National d'Art Moderne,
Centre Georges Pompidou

Both the black lines and the rectangles in
primary colours have disappeared. What
remains is a kind of rhythmical weave, in
which the vertical and horizontal coloured
strips run over and under each other.

explaining why, in his later years, Mondrian abandoned all the helpful theories
he had put together throughout his life to underpin the meaning of abstract art.
He was now certain that it was enough to live in order to be able to paint
correctly.

As "technician of the new", Mondrian was interested in expanding his range
of working materials. Coloured adhesive tape in the form of gummed paper
strips first appeared in New York at this time. Mondrian bought several rolls and
could now produce his pictures far more quickly than by the laborious process
of repeatedly overpainting the canvas. Some of the working sketches made from
adhesive tape have survived, including *New York City II* of 1942–44 (p. 87), and
other examples conceived by this method were completed as paintings, such as
New York City I (p. 86).

He had now come almost full circle, back to the random process of the grid
paintings of 1918/19 – perhaps this was what he had always been aiming for.
The brightly coloured grid paintings of 1919 had had a dryness and a
mechanical quality somewhat disturbing in pictures executed by traditional
techniques.

In order to make the end product work aesthetically, Mondrian needed new
pictorial media appropriate to his random approach. And he needed a new
technique which could express itself in his work as a harmony of technique,
material and design. The colourful linear pictures in Mondrian's New York City
series were excellent examples of just this ability to handle random arrangement
and to shift and regroup the elements in his pictures.

New York City II, 1942–44
Oil and paper on canvas, 119 x 115 cm
Düsseldorf, Kunstsammlung Nordrhein-Westfalen

In New York, Mondrian discovered a means of designing his strip paintings
by using the rolls of adhesive coloured tape which had just appeared at the
time. He moved the strips about until they were in the right position in
relation to each other and produced the desired rhythm on the background of
white canvas.

Broadway Boogie-Woogie, 1942/43
Oil on canvas, 127 x 127 cm
New York (NY), The Museum of Modern Art

In his last paintings, Mondrian pursued his dream of elevating works of
art to a vital, musical rhythm of pulsating coloured lights. Mondrian had a
passion for dancing and loved jazz. The title of this painting can be seen
as an indication of the conceptual proximity of Mondrian's new art to
boogie-woogie with its rhythmic syncopation.

None of the many European painters living in New York at that time was as close as Mondrian to contemporary American painting. He is thought to have been responsible for the discovery of Jackson Pollock, one of the most important painters of the fifties. Peggy Guggenheim, Mondrian's art dealer, is said to have been totally baffled by the chaotic tangle of lines in one of Pollock's paintings. Mondrian, however, allegedly told her that this was one of the most exciting pictures he had seen for a long time. Like Mondrian himself, Pollock had spent many years exploring the work of Picasso, and it is immediately obvious from many of his pictures, for example *Summertime* of 1948 (p. 84), that he was still using the essential Cubist elements of linear network and patches of colour. But Pollock painted equally well with coloured lines and from 1943 onwards he scattered an impulsive tangle of lines across the pictorial surface, giving it not one, but many centres and covering it evenly with forms. This style soon came to be known in America as "all-over" – Mondrian had known it since 1914.

The new epoch in painting emerging at that time is known today as Abstract Expressionism, an artistic position with formlessness as its ideal. Mondrian had always stood for clear, geometric form and in his last paintings he again attempted to combine the brightly coloured grid with coloured lines. His intention was to produce a musically shimmering tapestry of coloured particles and yet the result he produced in *Broadway Boogie-Woogie* of 1942/43 (p. 88), where each line is interrupted repeatedly by pulses of colour, evidently did not satisfy him.

Fritz Glarner
Piet Mondrian working on *Broadway Boogie-Woogie*, 1943
Photograph
Zurich, Kunsthaus, Glarner Archive

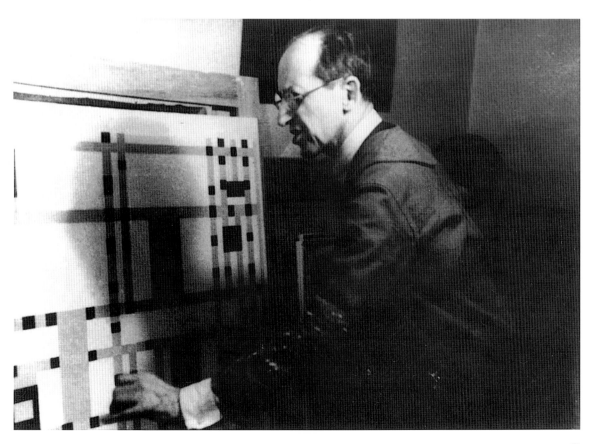

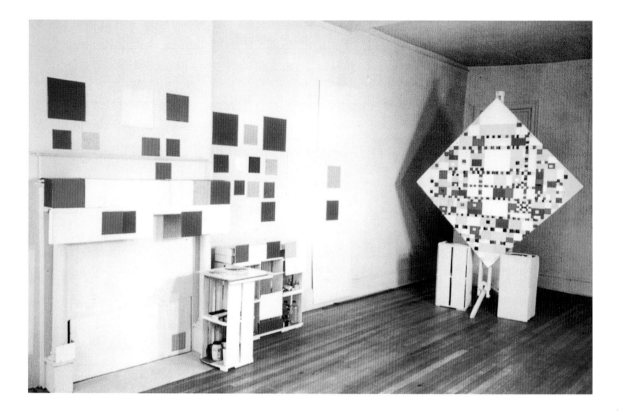

Fritz Glarner/Harry Holtzman
Piet Mondrian's studio in New York after his
death, 1944
Photograph
Zurich, Kunsthaus, Glarner Archive

Once again Mondrian incorporated the room as
a stage setting for his dreamed-of transition of
art into life. Geometric panels in the primary
colours, which dominated his paintings for
decades, are rhythmically disposed across the
walls.

Victory Boogie-Woogie (p. 91) goes even further – the forms are dissolved to the
point where the lines and planes are barely distinguishable from each other,
resulting in a wild rhythm of flickering effects. The title was probably chosen in
anticipation of the end of World War II. It was intended as the fusion of a great
political moment with the artist's personal victory over the traditional forms of
European painting. Here was one last proof of the historical necessity of
abstraction. This work, in which Mondrian was seeking to break new ground,
was left unfinished when he died in 1944.

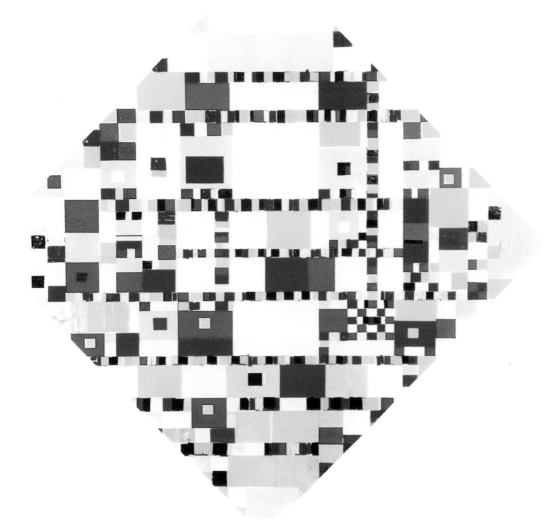

Victory Boogie-Woogie, 1943/44 (unfinished)
Oil and paper on canvas, diagonal 177.5 cm
Private collection

This last work by Mondrian, which was probably named in anticipation of
victory in the Second World War, remained unfinished when he died on
1 February 1944. The density, multiple colours and accentuation of the
linear grid convey an unusual sense of unrest, a new dynamism and
rhythmical transformation of the picture plane in the direction of an
increasingly formless, musically pulsating pictorial model.

Piet Mondrian – Life and Work

Piet Mondrian, 1892

Mondrian with his fiancée Greet Heybroek, c. 1914

1872 Pieter Cornelis Mondriaan is born in Amersfoort on 7 March, the second child of Pieter Cornelis Mondriaan, a teacher, and his wife, Johanna Christina Mondriaan, née Kok. Mondrian has one sister and three brothers – Johanna Christina (born 1870), Willem-Frederik (born 1874), Louis Cornelis (born 1877) and Carel (born 1880).

1892 Mondrian enters the Rijksakademie voor Beeldende Kunst in Amsterdam to study painting. He joins the Gereformeerde Kerk, and lives in the house of the Protestant publisher and politician, Johan Adam Wormser, until 1895.

1901 Mondrian's application for the Prix de Rome, a scholarship for young artists, is turned down a second time by the jury.

1904/05 He moves to Uden in Brabant to devote himself to landscape painting.

1906 He wins the Willink van Collen Prize and spends the winter on a farm near Oele together with the painter, Hulshoff-Pol.

1909 In January the Stedelijk Museum in Amsterdam puts on an exhibition of paintings by Mondrian and his painter friends Cornelis Spoor and Jan Sluyters. He joins the Theosophical Society. His mother dies.

1911 Mondrian takes part in the first exhibition by the Amsterdam artists' association, Moderne Kunstkring, in which works by Picasso and Braque are also shown. At the end of December he moves to Paris. He changes his name, and from now on calls himself Piet Mondrian, except in Holland.

1914 He returns to Holland and in 1916 moves into the artists' colony at Laren. H.P. Bremmer, the art historian and advisor to

Mondrian with friends at the "Voltaire" restaurant in Paris, 1930
from l. to r.: Robert Delaunay, Jean Arp, Henryk Stazewski, Florence Henri, Michel Seuphor, Brzekowski, Tine Vantongerloo, Theodor Werner with his wife, Sophie Taeuber-Arp, Piet Mondrian, Sonia Delaunay

European artists in exile in New York, 1942
1st row from l. to r.: Matta, Ossip Zadkine, Yves Tanguy, Max Ernst, Marc Chagall, Fernand Léger
2nd row from l. to r.: André Breton, Piet Mondrian, André Masson, Amédée Ozenfant, Jacques Lipchitz, Tchelitchew, Kurt Seligmann, Eugène Berman

1938 He moves to London in September, where he lives with the artists, Ben Nicholson and Barbara Hepworth in their Hampstead home.

1940 In September he sets sail for New York. There he shows with the American Abstract Artists and in many exhibitions. He appoints Harry Holtzman as his sole heir.

1941 His autobiographical text *Toward the True Vision of Reality* is published.

1944 Piet Mondrian dies of pneumonia on 1 February. His last work, *Victory Boogie-Woogie*, is left unfinished.

the art collector Mrs Kröller-Müller, pays him an annual retainer.

1917 He contributes to the magazine *De Stijl*, published monthly from October 1917 onwards by Theo van Doesburg.

1919 He returns to Paris in the summer. Bremmer cancels his annuity.

1920 At the beginning of the year Mondrian plans to give up painting. His book on art theory, *Le Néo-Plasticisme*, is published in Paris.

1921 Mondrian's father dies.

1925 Mondrian's book *Neue Gestaltung* is published in Germany as no. 5 in the *bauhausbücher* series.

1926–1931 Mondrian produces designs for a private library and for stage sets. He writes articles on the new architecture and city planning, which appear in the periodical *i 10*, published by the anarchist Arthur Müller-Lenning. Mondrian takes part in exhibitions by the artists' groups Cercle et Carré and Abstraction-Création. International collectors, including the Americans Katherine S. Dreier and A.E. Gallatin, buy many of Mondrian's paintings. He cannot find a publisher for his book *The New Art – The New Life*.

1930 He is commissioned to paint a picture for the new Town Hall in Hilversum.

1932 A retrospective exhibition is mounted by the Stedelijk Museum in Amsterdam to mark his sixtieth birthday. He is commissioned to paint a picture to be presented to the Haags Gemeentemuseum in The Hague.

Fritz Glarner, Mondrian in his studio, New York, 1943

Bibliography

Writings by Mondrian

Robert P. Welsh and Joop M. Joosten (eds.), *Two Mondrian Sketchbooks 1912–14*, Amsterdam 1969

Piet Mondrian, De Nieuwe Beelding in de Schilderkunst, in: *De Stijl*, Vol. 1, 1917–18, No. 1 to Vol. 1, 1917–18, No. 12

Piet Mondrian, Natuurlijke en abstracte realiteit. Trialoog (gedurende een wandeling van buiten naar de stad), in: *De Stijl*, Vol. 2, 1918–19, No. 8 to Vol. 3, 1919–20, No. 2

Piet Mondrian, *plastic art and new plastic art 1937 and other essays 1941–43*, The documents of modern art, New York 1951

Hans L. Conrad Jaffé (ed.), *Mondrian und De Stijl*, Cologne 1967

Piet Mondrian, *Neue Gestaltung*, Mainz 1974 (reprint of bauhausbuch no. 5)

Harry Holtzman and Martin S. James (ed. and transl.), *The New Art – The New Life. The Collected Writings of Piet Mondrian*, London 1987

Other authors (selection)

Cor Blok, *Piet Mondriaan. Een catalogus van zijn werk in Nederlands openbaar bezit*, Amsterdam 1974

Carel Blotkamp, *Mondriaan in detail*, Utrecht/Antwerp 1987

Kermit Swiler Champa, *Mondrian Studies*, Chicago/London 1985

Susanne Deicher, *Piet Mondrian. Protestantismus und Modernität*, Berlin 1994

Herbert Henkels (ed.), *Albert van den Briel: 't is alles een groote eenheid, Bert. Piet Mondriaan, Albert van den Briel en hun vriendschap*, Haarlem 1988

Hans L. Conrad Jaffé, *De Stijl 1917–1931. Der niederländische Beitrag zur modernen Kunst*, Frankfurt/Berlin/Vienna 1965
Hans L. Conrad Jaffé, *Piet Mondrian*, Cologne 1990

Jacques Meuris, *Piet Mondrian*, Paris 1991

John Milner, *Mondrian*, London 1992

Maria Grazia Ottolenghi (ed.), *L'Opera Completa di Mondrian*, Milan 1974

J. J. Oud and L. J. F. Wijsenbeek, *Mondriaan*, Zeist/Antwerp 1962

C. L. Raggianti, *Mondrian e l'arte del XX secolo*, Milan 1962

Michel Seuphor, *Piet Mondrian: Leben und Werk*, Cologne 1957

Clara Weyergraf, *Piet Mondrian und Theo van Doesburg. Deutung von Werk und Theorie*, Munich 1979

Beat Wismer, *Mondrians ästhetische Utopie*, Baden 1985

Exhibition Catalogues (selection)

Piet Mondrian 1872–1944, Centennial Exhibition, The Solomon R. Guggenheim Museum, New York 1971

Mondrian. Zeichnungen, Aquarelle, New Yorker Bilder, Staatsgalerie Stuttgart 1980

Mondrian. From figuration to abstraction, The Haags Gemeentemuseum 1987

Piet Mondriaan. Een Jaar in Brabant 1904/1905, Den Bosch 1989

Mondriaan aan de Amstel, Amsterdam 1994

Susanne Deicher

born 1959, gained her doctorate in 1993 with a thesis on Piet Mondrian. Taught in Berlin, Maastricht and Tübingen. Works as freelance writer; published *Die weibliche und die männliche Linie. Das imaginäre Geschlecht der modernen Kunst*, Berlin 1993.

Acknowledgments

The publishers wish to thank the museums, collectors, archives and photographers for granting permission to reproduce illustrations and for their friendly assistance during the production of this book. In addition to the collections and institutions mentioned in the captions, the following acknowledgements are also due:

Jörg P. Anders, Berlin: 18 below
Herbert Boswank, Dresden: 65 below
Angela Bröhan, Munich: 54

Martin Bühler, Öffentliche Kunstsammlung Basel, Basle: 51, 59, 77
Susanne Deicher, Berlin: 12 below, 20 left, 28 below
A. E. Gallatin, New York: 75
David Heald, New York: 47, 63, 81 above right
Jürgen Karpinski, Dresden: 10 above
Tim Koster, RBK The Hague: 53 below, 54 below, 64
Rheinisches Bildarchiv, Bonn: 60
Charles Uht, New York: 35